IMAGES
of America

PHILADELPHIA
RADIO

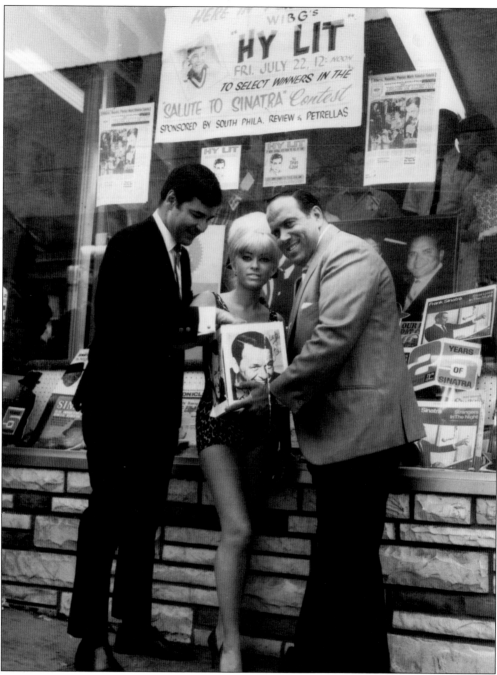

WIBG's Hy Lit (left), an unidentified model, and Nick Petrella pick winners in the Salute to Sinatra contest outside Petrella's record shop in South Philadelphia around 1966. (Courtesy of HyLitRadio.com.)

ON THE COVER: Philip Gadsden, president of the Philadelphia Chamber of Commerce, officiates at the start of a new radio series on February 19, 1931. The chamber of commerce utilized the facilities of WPEN at Twelfth and Walnut Streets. (Courtesy of the Historical Society of Pennsylvania.)

IMAGES
of America

PHILADELPHIA
RADIO

Alan Boris

ARCADIA
PUBLISHING

Published by Arcadia Publishing
Charleston, South Carolina

Printed in the United States of America

Library of Congress Control Number: 2010939733

For all general information, please contact Arcadia Publishing:
Telephone 843-853-2070
Fax 843-853-0044
E-mail sales@arcadiapublishing.com
For customer service and orders:
Toll-Free 1-888-313-2665

Visit us on the Internet at www.arcadiapublishing.com

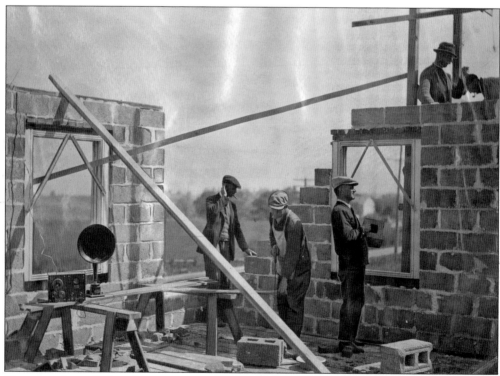

One year after radio broadcasting commenced in Philadelphia, these builders in Kennett Square were already listening at work. The men installed a radio set and connected it to an amplifier so that they could hear the *Music Week* concert broadcasts. (Courtesy of Temple University Libraries, Urban Archives, Philadelphia, Pennsylvania.)

CONTENTS

PREFACE

Alan Boris has written the book I always wanted to write but never did.

As a former broadcast manager and producer, I love Philadelphia radio. In fact, my grandfather worked at one of the stations in town and my mother sang on the *Uncle WIP* show, so you could even say it is in my blood.

Born right after the Second World War, I grew up in the City of Brotherly Love, listening to the town's area radio stations. As a preteen, I listened to the legendary Joe Niagara, Hy Lit, and Bill Wright Sr. As a young adult, I experienced the birth of Famous 56, WFIL, in 1966. After college, I got into the industry and worked with people like Niagara, Lit, Jerry Blavat, and the legendary soul DJs like Georgie Woods, Jimmy Bishop, Dr. Perry Johnson, and Butterball.

I remember going to the Tower to see Hy Lit, a dozen rock and roll artists, and a double feature for 99¢ (An apt price, as Hy was on WIBG, Radio 99). I went to the old Nixon Theater to see Georgie Woods and a host of soul artists—again with a double feature. I remember the days of the Uptown and the great musical shows that played there.

As a broadcast historian, I can truthfully say that Alan has done a huge amount of research and gotten it all correct. I am delighted that Alan has spent the time to document Philadelphia radio and add to the historical record. I often remind those around me that history is only what gets preserved.

Above all, radio is about the lost art of imagination. Whether you are listening to an old-time radio drama or tuning in to a current disc jockey telling a story, radio enables you see things that a camera could never capture.

In this book, Alan Boris has built a time machine. Not of wires and secondhand electronics, but one just as real. The wonderful photographs and stories compiled here open a window to the past—to the days of radio, the days of imagination.

For anyone with even a passing interest in Philly radio, this is a must read (I have already read it twice).

As Joe Niagara would have said, this book "is up there where the air is rare."

—Gerry Wilkinson
Chairman of the Board of the Broadcast Pioneers of Philadelphia
January 25, 2011

ACKNOWLEDGMENTS

This book would not have been possible without the assistance of current and former employees of Philadelphia radio stations who provided photographs, stories, and their time: Wynne Alexander, Sam Lit, Don Lancer, Pierre Robert, Jason Fehon, David Custis, Mel Taylor, Dave Shayer, Mel Klawansky, Randy Roberts, Jerry Blavat, Bob Leonard, Sonny Fox, Cyndy Drue, Byron Paul, Ed Higashi, Barry Reisman, Art Ellis, Harry Neyhart, Michael Tearson, Dean Tyler, and to historian and Chairman of the Board of the Broadcast Pioneers Gerry Wilkinson for reviewing my manuscript. Thanks also to the following people that went out of their way to assist me: Judy Sciaky, Frank Lipsius, Linda Seyda and the excellent staff of the Free Library of Philadelphia, the Temple University Urban Archives, and the Philadelphia Department of Records. Special thanks to my friend Diana Cammarota who helped organize this massive effort; my wife, Caren Gurmankin, for her support and patience; and Lucky the dog, for keeping me company during long hours of writing.

Unless otherwise noted, all images are from the author's collection.

INTRODUCTION

The first time radio caught my attention was 1983 when the radio in my middle school art class was always tuned to WCAU-FM. At that time, the station played a format called Hot Hits, featuring the top pop-rock music of the day with catchy jingles and fast-talking disc jockeys. From that point forward I would not only listen to as much Philadelphia radio as possible, but also begin to study the story behind its evolution. This book illustrates the first 90 years of Philadelphia radio and takes a look at the fascinating trends and changes in technology, business, and entertainment that forms the basis of where radio is today.

Although inventors and enthusiasts had been experimenting with sending voice and music through the air since 1906, radio broadcasting did not begin in Philadelphia until 1922. That winter, WGL became the first licensed commercial station, broadcasting from a private residence on North Broad Street. Hundreds of people across the city listened to the broadcasts, and many sent letters to the station commenting on the quality of the programming. At least six more stations signed on in Philadelphia by the end of the year as the nation experienced a craze in everything related to radio.

The city's early stations came from a variety of entrepreneurs and devotees, most of whom had an interest in stimulating the sale of radio sets and radio parts. For instance, electrician Wilson Durham founded WCAU in the back of his electrician's shop on Market Street and the Lennig Brothers started WNAT in their radio supply company on Spring Garden Street. Philadelphia department stores operated four stations and opened lavish radio departments. Gimbel Brothers' WIP and Stawbridge and Clothier's WFI both went on the air the same day in March 1922 and featured speeches by Gov. William Cameron Sproul and Mayor J. Hampton Moore. Other programming on the inaugural day included soprano soloists, reading of the local newspapers, prominent singers, and moving picture stars giving a short talk.

On December 10, 1923, thousands of Philadelphians heard what had previously only been heard by a chosen few—the voice of the president of the United States. Wanamaker's WOO station and others across the country connected through telephone lines broadcast Pres. Calvin Coolidge's eulogy for former president Warren Harding. It was the first time a president had spoken specifically for a radio audience, and listeners marveled at the wonder of radio. One of the most discussed aspects of the speech, however, was the noticeable Boston accent detected in the president's voice.

Until about 1925, most listeners built their own radios, utilizing numerous magazines and newspaper articles describing how to build crystal sets or more sophisticated devices. By the mid-1920s, many companies, including Philadelphia's own Atwater Kent, Philco, and Music Master, were manufacturing traditional radios constructed in huge cabinets, joining other pieces of furniture in people's living rooms.

The 1930s were known as the traditional golden age of radio, when prime-time dramas and live music via national radio networks provided home audiences with their evening's entertainment.

Strawbridge and Clothier's WFI and Lit Brothers' WLIT were early affiliates of the NBC Red Network, featuring shows such as *The A&P Gypsies, Eddie Cantor,* and *The Goldbergs.* Other popular programs from this period included *Fibber McGee and Molly, Lux Radio Theatre,* and *The Shadow.*

WCAU was a flagship affiliate of CBS and was known for its strong roster of popular stars, including Bing Crosby, Al Jolson, George Burns and Gracie Allen, and Kate Smith. In addition to its network offerings, WCAU provided memorable homegrown talent, such as Stan Lee Broza, host of *The Horn & Hardart Children's Hour,* and Powers Gouraud, known as "the Old Night Owl."

The radio networks had a profitable run as the major source of prime-time entertainment until the early 1950s when television broadcasting became widespread. By 1954, many of the top radio stars had fled for television, and the audiences and sponsors followed them. Network radio was in a tailspin, and many at the time joked about the imminent death of radio. However, radio did manage to survive by reinventing itself and complementing, rather than directly competing with, television.

The widespread reliance on records and disc jockeys was one of the biggest elements of radio's new success. Gone were the expensive orchestras, actors, directors, and support staff needed to create live entertainment. The goal became to attract and hold a specific audience, often one that was largely ignored by television. In Philadelphia, WHAT and WDAS were programmed to appeal to the underserved black audience and were met with a great deal of success.

Radio stopped trying to entertain the broadest possible audience and concentrated on appealing to specific groups. WIBG and, later, WFIL found huge success using rock and roll to appeal to a mainly teenage audience. Other stations such as WIP and WPEN fell into the middle of the road category that attracted a slightly older crowd. This was known as formula radio, where research and ratings were used to determine exactly which songs to play in order to reach the target audience. Eventually, at least a dozen formats from all news to country were devised to meet different goals.

Advances in technology also played a part in radio's rebirth. By the 1950s, radios were no longer limited to being pieces of furniture in the living room. They were being placed in kitchens, bedrooms, garages, and, eventually, even pockets. The popularity of the car radio coincided with the growth of the suburbs, and radio was there to share the longer commute. Radio could now be a constant companion from sunrise to bedtime. People began to realize that they could listen to radio all day and their eyes were free to do something else.

As AM radio was basking in its new success in the 1950s and 1960s, the FM dial was relatively quiet. Most FM stations were simply duplicating the same audio heard on their AM sister stations. Frequently unprofitable with few listeners, these operations were kept alive by owners with the hope that FM would catch on someday. A few pioneers began experimenting with original programming that was optimized for FM's cleaner signal and stereo sound. George Voron's WQAL and David Kurtz's WDVR played lush instrumental versions of popular songs known as beautiful music, and at WHAT-FM, Sid Mark was leading an all-jazz format. Even with these unique offerings, the number of listeners to all of Philadelphia FM stations combined was slightly less than the most popular AM station's audience.

It took the young, counterculture crowd to finally catapult FM into the mainstream with a progressive, underground format. The songs were usually longer than the typical three-minute pop tune, and they were played in long, thematic sets of music. All of the mainstays of popular AM radio were intentionally shunned: jingles, frequent newscasts, talking over the music, and the utilization of any charts or research. The disc jockeys picked their own music, often from their own library of albums. WDAS-FM, WMMR, WIFI (now WXTU), and WIOQ offered a progressive format at some point in the late 1960s through the mid-1970s.

As more and more listeners flocked to progressive FM stations, the format's success came to be its undoing. Once management saw that there were profits to be made on FM, most of the decisions were taken out of the hands of the disc jockeys and into upper management's. Research tools and consultants helped to fine tune the audience and optimize revenue. The progressive

period did not last long, but it was a proving ground for FM, and there was no turning back the tide of listeners that were starting to check out the FM band.

In 1979, the number of people listening to FM surpassed AM for the first time, and that trend continued to increase. One by one, the city's once mighty AM stations dropped most music in favor of news, talk, religion, or ethnic programming. WIP was one of the last holdouts with current mainstream music on AM. After a strong run in the 1970s, WIP gradually replaced their music programming with sports talk, and by 1988, all the music had disappeared. With FM in the mainstream, the total radio audience was now spread out over more stations than ever. The era of a single station dominating the radio audience, as WIBG and WFIL had once done, was over.

During the 1980s, the government relaxed many rules covering the radio industry. This made stations more appealing to investors, and over half of the radio stations in Philadelphia changed hands during the decade. The Telecommunications Act of 1996 further relaxed media ownership rules. The number of stations one company could own in Philadelphia increased from four to eight. This led to another frenzied round of buying and selling of stations in the late 1990s. As a result, many popular Philadelphia stations were clustered into the hands of just a few owners, chiefly Clear Channel Communications, CBS Radio, and Greater Media, who combined own about half of the city's commercial stations and an even greater share of the listeners.

Today's new media such as mobile devices, satellite radio, Internet streaming, and social media are the latest threats to radio. Overall radio listening is declining, and a whole generation has now grown up without radio as their primary means of discovering new music. While the urgency to reinvent itself may not be as acute as it was when television threatened it in the 1950s, the challenges of keeping radio alive and relevant are still very real. The last 90 years, however, have demonstrated the staying power of radio, and it is clear that as long as it continues to find ways to connect with listeners, listeners will find a way to connect to it.

One

EARLY RADIO BROADCASTING

Radio was developed through a series of inventions over several years, beginning with Marconi's wireless telegraph in the 1890s. It took the work of many more inventors and visionaries, such as Reginald Fessenden, Lee de Forest, Edwin Armstrong, and David Sarnoff to develop radio as it is known today.

By 1921, all of the pieces were in place for broadcasting to commence on a large scale; stations were already on the air in Newark, Boston, Chicago, and Pittsburgh. With just a few spare parts, which typically included an oatmeal box, some wire, a crystal, and earphones, anyone could build a radio and magically pull voices and music out of the air. The following year saw a boom in radio broadcasting in Philadelphia, as well as across the country, as the number of licensed stations jumped from 30 to 556 in just one year.

For a few years, the increasing number of stations interfering with each other's signals created bedlam on the airwaves. In order to help manage the new medium, President Coolidge signed the Radio Act of 1927, which led to the formation of the Federal Radio Commission, a forerunner to the FCC. The commission carefully reallocated the existing band, resulting in reduced interference among stations.

At the same time, radios were getting more sophisticated. Sensitive tube-based radios started to replace the temperamental crystal sets in the early 1920s. At first, factory-built radios were priced out of reach for most, but by 1928, more affordable radios that ran on standard house electricity were available.

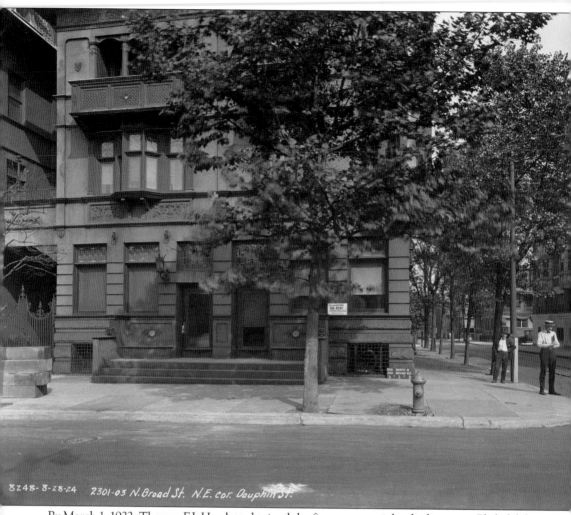

8248-8-28-24 2301-03 N. Broad St. N.E. cor. Dauphin St.

By March 1, 1922, Thomas F.J. Howlett obtained the first commercial radio license in Philadelphia for station WGL, located in his home at 2303 North Broad Street. WGL was mostly a hobby for Howlett, who was in the steamship business and regularly used his equipment to talk to ships at sea. Howlett reportedly spent $20,000 building his radio station, which included two rooftop towers 178 feet above ground and a 3,000-watt generator. Programming consisted of live orchestras, records, soloists, and even the airing of telephone calls made to his home. At one point in the spring of 1922, during one of his broadcasts, the telephone operator informed Howlett that there were 500 calls waiting for him through every one of the city's exchanges, at which point he ended the show. This photograph depicts Howlett's 32-room home as it appeared in 1924, the year that he closed down the station to concentrate on his business. (Courtesy of PhillyHistory.org, a project of the Philadelphia Department of Records.)

This advertisement for Strawbridge and Clothier's radio station WFI appeared in the *Philadelphia Inquirer* on March 17, 1922. The next day, the station began regular programming at 10:16 a.m. with an address by John F. Braun, president of the Art Alliance and of the Music League. The Strawbridge and Clothier Male Quartette participated in the first broadcast. Ednyfed Lewis (shown second from left) was general manager of WFI from 1933 to 1934. In 1934, WFI merged with WLIT to form WFIL. Harold Simonds (third from left) was with the station for 41 years. (Both, courtesy of the Theatre Collection, Free Library of Philadelphia.)

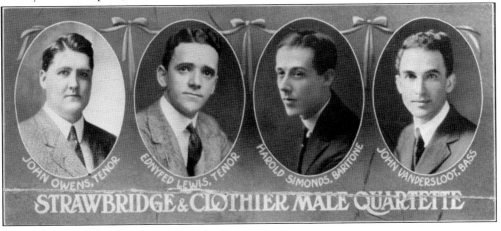

JOHN OWENS, TENOR — EDNYFED LEWIS, TENOR — HAROLD SIMONDS, BARITONE — JOHN VANDERSLOOT, BASS

STRAWBRIDGE & CLOTHIER MALE QUARTETTE

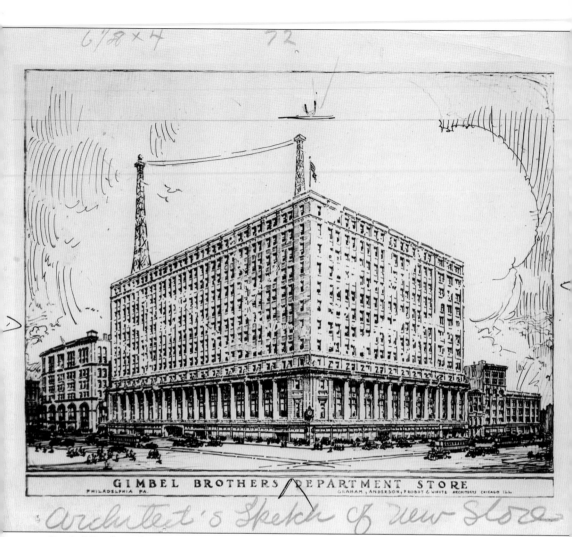

GIMBEL BROTHERS DEPARTMENT STORE
PHILADELPHIA PA. GRAHAM, ANDERSON, PROBST & WHITE ARCHITECTS CHICAGO ILL.

Gimbel Brothers department store celebrated inaugural ceremonies for its new station, WIP, 44 minutes after WFI debuted on March 18, 1922. This date marks the beginning of major broadcasting in Philadelphia, as the only existing station at the time, WGL, had a sporadic schedule. Despite the fact that direct advertising was frowned upon in the early years of broadcasting, the department store stations such as WIP were clearly designed to promote the store and bring in shoppers. While specific product descriptions and prices were rarely mentioned, the name of the store and its street address was announced regularly. Performers often integrated the store's name into their character, such as Uncle WIP. After selling airtime became common in the late 1920s, the department stores found it cheaper to purchase blocks of time from other stations rather than running their own. (Courtesy of the Historical Society of Pennsylvania.)

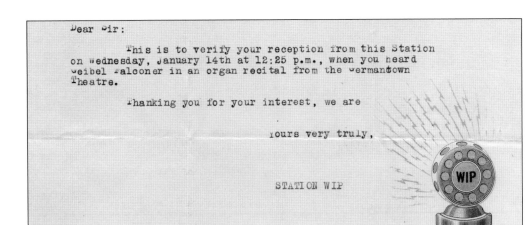

Dear Sir:

This is to verify your reception from this Station on Wednesday, January 14th at 12:25 p.m., when you heard Weibel Falconer in an organ recital from the Germantown Theatre.

Thanking you for your interest, we are

Yours very truly,

STATION WIP

Before structured radio ratings services became available in the 1930s, the volume of mail response was considered an excellent measuring stick for judging the success of a program. Listeners frequently sent letters to stations containing feedback on the quality of their programming. In addition, some hobbyists requested verification of reception cards, also known as QSL cards, which most stations provided upon request (and some still do to this day). Several listeners collected these cards and proudly displayed them to prove reception of a distant station. (Both, courtesy the Mike Schultz collection.)

GIMBEL BROTHERS
PHILADELPHIA

RADIO BROADCASTING—W I P, 509 METERS

3/6 , 1924

We are glad to get your letter regarding W I P broadcasting.

W I P broadcasts now on 509 meters, as doubtless you know.

We shall be pleased to have your suggestions and shall appreciate your continued interest in W I P.

Yours truly,

The Gimbel Radio Station (W I P) is enclosed in glass to be seen and enjoyed by all.

LIT BROTHERS

RADIO BROADCASTING STATION
WLIT
MARKET-EIGHTH-FILBERT-SEVENTH-STS.
PHILADELPHIA

The Lit Brothers department store station signed on as WDAR in 1922 after all of the three-letter call combinations were exhausted. The store obtained new customized call letters WLIT in 1925. Initially, all Philadelphia stations shared the same frequency and divided the day with each other. By 1923, more frequencies were made available to broadcasters but not yet enough for every station to have its own slot. WFI shared the same frequency with WLIT on alternating nights until both stations consolidated as WFIL in 1935. It was up to the stations to work out their own arrangements for sharing time on the same frequency. In some parts of the country, this led to "jamming wars," but Philadelphia stations were usually able to amicably work together. (Courtesy of the Mike Schultz collection.)

Instructor William Thomas (left) explains the operation of a crystal set to Russell Casserly at Thomas Junior High School in Philadelphia on April 1, 1922. Crystal sets were simple and inexpensive radio receivers that were popular in the earliest days of broadcasting. The devices were often homemade and built by those who were interested in learning about the theory behind radio technology. (Courtesy of Temple University Libraries, Urban Archives, Philadelphia, Pennsylvania.)

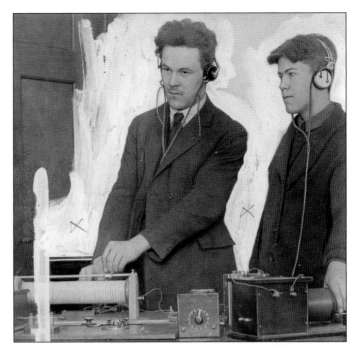

The Sesqui-Centennial International Exposition of 1926 was a world's fair hosted in Philadelphia in the area now home to the sports complex in South Philadelphia. Pictured here is the Stromberg-Carlson radio exhibit. By 1926, radios that ran on house current instead of batteries were available, and loudspeakers were widely obtainable, though often as an add-on option. (Courtesy of PhillyHistory.org, a project of the Philadelphia Department of Records.)

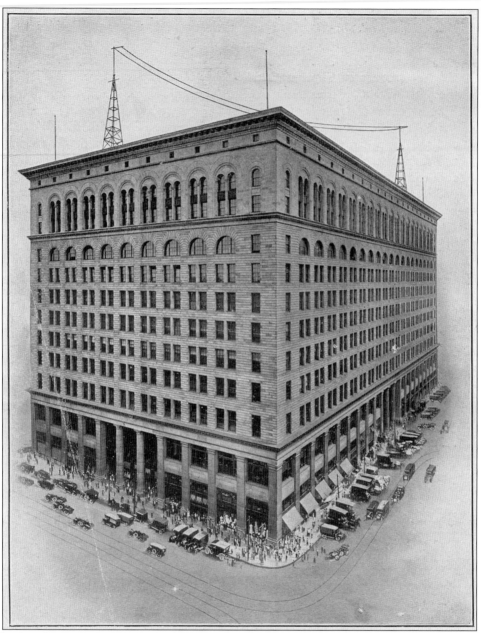

The famed Wanamaker's pipe organ dominated the comparatively highbrow WOO radio schedule. In an attempt to capture the organ's wide range of tones, the station experimented with new condenser-type microphones instead of the then standard carbon microphones that had a limited pickup range. The new microphone was successful in capturing the sounds of the organ, and it eventually became the radio industry standard. Compared to the early radio schedules of the other Philadelphia department store stations, WOO had the least programming variety, relying heavily on organ music and time signals from the naval station in Arlington, Virginia. In 1925, WOO became an affiliate of the WEAF chain, the forerunner to NBC. In 1928, Wanamaker's decided that the station was too expensive to maintain and did not contribute to the store's bottom line, at which point it was shut down. (Courtesy of the Historical Society of Pennsylvania.)

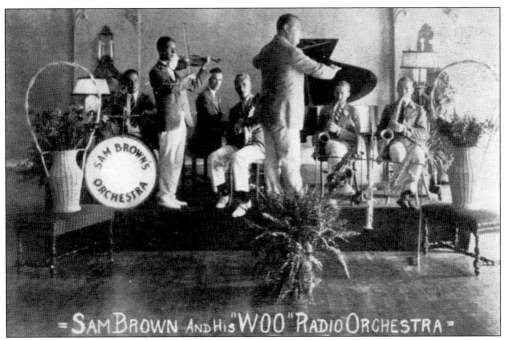

= SAM BROWN AND HIS "WOO" RADIO ORCHESTRA =

In the early days of broadcasting, many stations had one or more house bands such as the WOO Radio Orchestra led by Sam Brown, seen here in 1923. Initially, it was considered demeaning for a station to play records instead of broadcasting live music.

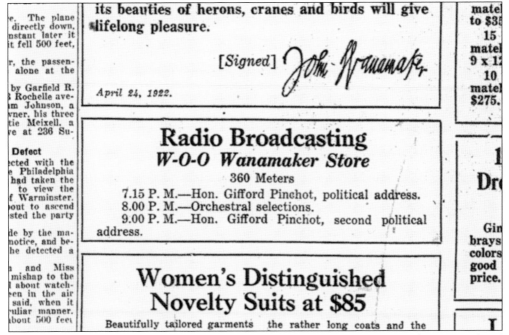

its beauties of herons, cranes and birds will give lifelong pleasure.

[Signed] *John Wanamaker*

April 24, 1922.

Radio Broadcasting
W-O-O Wanamaker Store
360 Meters

7.15 P. M.—Hon. Gifford Pinchot, political address.
8.00 P. M.—Orchestral selections.
9.00 P. M.—Hon. Gifford Pinchot, second political address.

Women's Distinguished Novelty Suits at $85

Beautifully tailored garments the rather long coats and the

Department stores printed their schedules as part of larger advertisements they ran in local newspapers. Eventually, newspapers created a dedicated section for radio listings. The schedule above is from WOO's inaugural broadcast on April 24, 1922. Four months later, the station installed a significantly stronger transmitter and held a second inauguration.

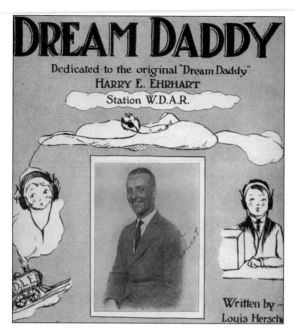

DREAM DADDY

Dedicated to the original "Dream Daddy"
HARRY E. EHRHART
Station W.D.A.R.

Written by —
Louis Hersch

Harry Ehrhart, a former telephone company repairman and World War I veteran, was the original Uncle WIP for Gimbel's department store when the station signed on in 1922. The radio character was so popular with children that hundreds would flock to the store to see him. When Ehrhart accepted an announcer position at rival Lit Brothers' station WDAR, he took on the name "Dream Daddy" and continued as a popular children's show host. Uncle WIP was then portrayed by Christopher Graham, seen below at a Willow Grove appearance in 1924. Graham continued as Uncle WIP until his death around 1932, at which point others took on the role. (Below, courtesy of Temple University Libraries, Urban Archives, Philadelphia, Pennsylvania.)

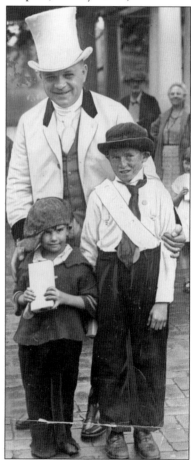

Two

THE GOLDEN AGE

The 1930s and 1940s are often remembered for the variety of comedies, thrillers, soap operas, and dramas delivered by the radio networks. One of the most popular shows from this period was *Amos 'n' Andy*, carried by the NBC network with an estimated national audience of 40 million. Radio entertainment offered a free escape from the effects of the Great Depression.

There were now over 19 million radio sets in the country, and they were becoming an essential part of daily life. For many, the radio was now a more necessary possession than the refrigerator or telephone. Advertisers noticed this and soon developed short, snappy commercials and jingles to sell their products.

Notable events from the golden age include the start of President Roosevelt's fireside chats and the widespread panic generated by Orson Welles's production of *The War of the Worlds* in 1938 (many listeners believed the mock news accounts of Martians invading the Earth were real). In Philadelphia, this period in radio was punctuated by the construction of grand buildings to house popular stations such as WCAU and KYW. As the flagship station of CBS, WCAU contributed 18 hours a week to the network and retained two house bands. Network programming continued to be the source of entertainment for families gathered around the radio until the widespread adoption of television in the late 1940s. Stations did not let go of old radio easily, and as late as 1956, WCAU was still putting on shows for large live audiences.

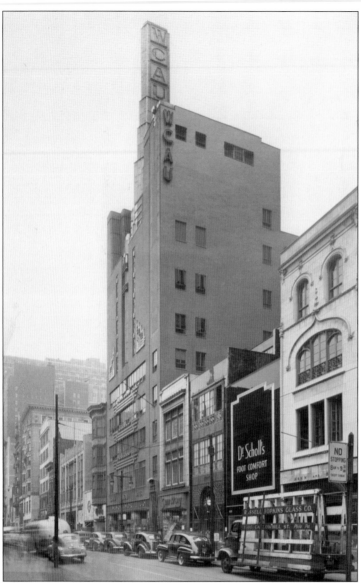

The WCAU Building at 1622 Chestnut Street was completed in 1932 and became home to the station in 1933. The Art Deco–style building was the first ever constructed specifically for radio broadcasting and included eight studios (one big enough to accommodate the Philadelphia Orchestra) and a technical lab where conductor Leopold Stokowski experimented to perfect the transmission of live music. WCAU-TV operations were added in 1948. In 1952, the stations moved to Bala Cynwyd, and today, the building is home to the Art Institute of Philadelphia. What no longer remains is the large WCAU tower that formed an after-nightfall landmark visible for miles. (Left, courtesy of the Library Company of Philadelphia; below, courtesy of the Theatre Collection, Free Library of Philadelphia.)

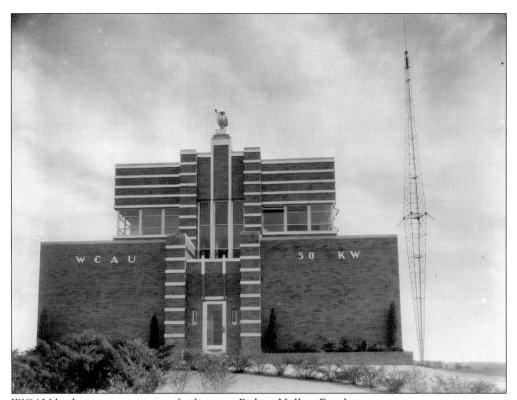

WCAU built new transmitting facilities on Bishop Hollow Road in Newtown Square that went into use in September 1932. Programming was delivered to the site via telephone lines from the station's Philadelphia studios. After a series of power increases, WCAU had received a desirable 50,000-watt clear channel status, which meant that under certain atmospheric conditions, its signal could be heard in several countries. In addition to the main WCAU signal, the station also broadcast a shortwave signal in an attempt to reach an even larger worldwide audience. In 1941, WCAU moved its transmitting facilities to a more technically favorable location in Moorestown, New Jersey, and the Newtown Square operation was shut down. The building was demolished, and the 500-foot tower was torn down; its 35 tons of steel donated to the war effort. (Both, courtesy of the Historical Society of Pennsylvania.)

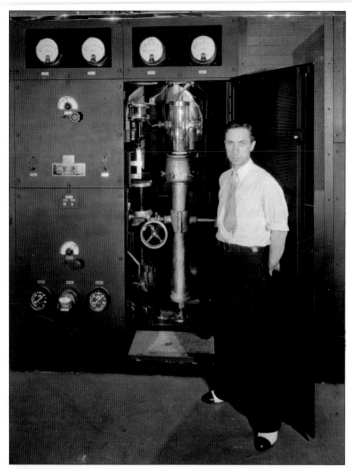

WCAU engineer Edward Bieler is seen standing beside a safety door at the station's new 50,000-watt amplifier in Newtown Square. One of the 100,000-watt tubes used by the apparatus is visible inside the unit. (Courtesy of the Historical Society of Pennsylvania.)

WCAU's 50,000-watt transmitter was built by the RCA-Victor Company of Camden under the direction of John G. Leitch, the station's technical supervisor. (Courtesy of the Historical Society of Pennsylvania.)

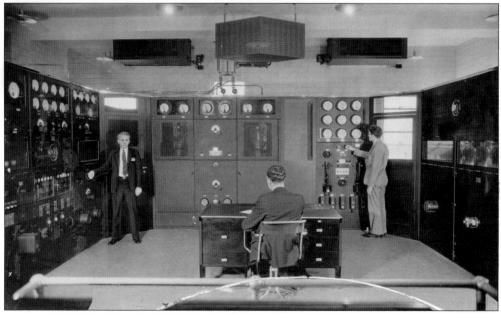

The Ninth Annual Electric and Radio Show was held in Philadelphia in 1936. WCAU operated a remote broadcast (right) as electrical and appliance representatives peddled their wares. Fred Ostendorf (below) of Beach Haven, New Jersey, was the first customer at the show to buy a radio. He became the proud owner of a nine-tube RCA Victor model listed at $118.50—equivalent to $1,814 in 2009, factoring inflation. (Both, courtesy the Historical Society of Pennsylvania.)

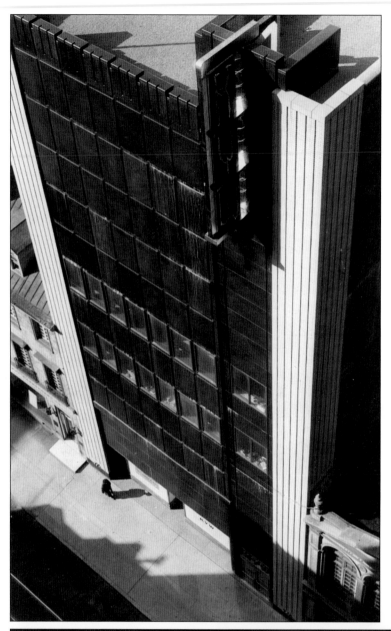

When KYW moved to Philadelphia from Chicago in 1934, its studios and sales operations were initially handled by WCAU personnel out of their offices on Chestnut Street. In 1938, the station moved into the newly completed $600,000 KYW Building at 1619 Walnut Street. KYW remained at this location until 1972, when it moved to a newly constructed building at Fifth and Market Streets. Upon vacating 1619 Walnut Street, the building was donated to Temple University. Restaurant Brasserie Perrier occupied the ground floor in the early 2000s. (Left, courtesy Temple University Libraries, Urban Archives, Philadelphia, Pennsylvania; below, courtesy of the Theatre Collection, Free Library of Philadelphia.)

WESTINGHOUSE RADIO

LOCUST 3760 KYW PHILADELPHIA News

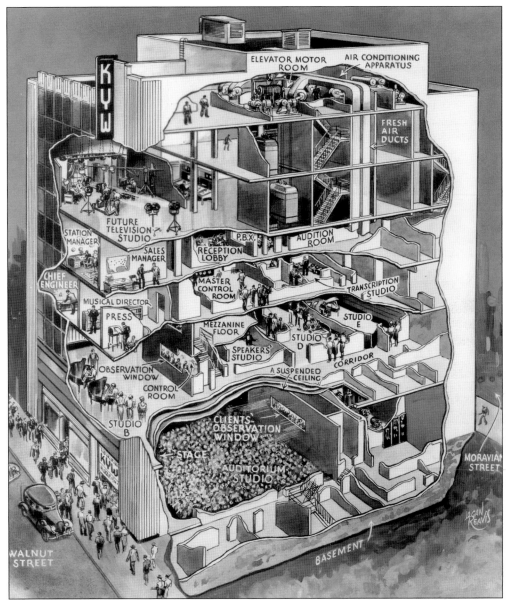

This cross-section view of the KYW Building in 1938 shows that just a small portion of the building was devoted to future television use; the majority of the space was devoted to the AM station. As the golden age came to an end, much of the space used for musicians and live entertainment was turned over to television. This sketch was created by Logan Reavis, a local artist and former Philadelphia newspaperman. (Courtesy of Temple University Libraries, Urban Archives, Philadelphia, Pennsylvania.)

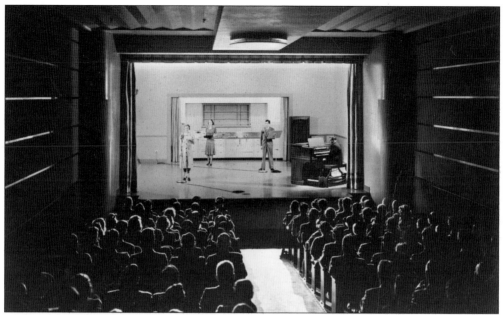

One of the unique features of the new KYW Building was the subsurface studio auditorium. Initially, the space was used for producing radio shows with live audiences. As that type of programming was phased out in favor of television, the area was turned into a small television studio. The *Mike Douglas Show* used this studio starting in 1965, which, at the time, seated 140 people. (Courtesy of Temple University Libraries, Urban Archives, Philadelphia, Pennsylvania.)

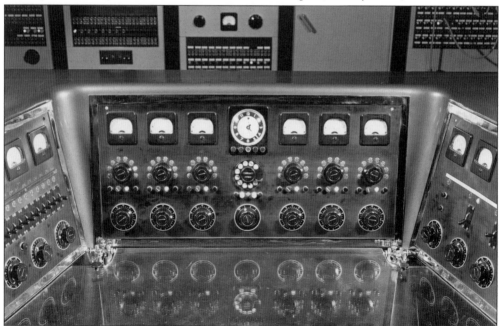

Pictured here is the console of KYW's master control room as seen on June 5, 1938, shortly after KYW moved into their new building. Typically, master control would be utilized to route audio feeds throughout the facilities. (Courtesy of Temple University Libraries, Urban Archives, Philadelphia, Pennsylvania.)

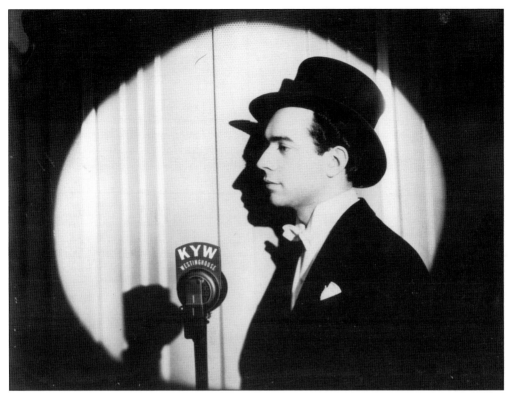

Jan Savitt was a Russian-born American bandleader, music arranger, and violinist who attended the Curtis Institute of Music. He was the youngest member of the Philadelphia Orchestra at the time of his admission. In 1934, Savitt formed a house band at WCAU and was the station's music director. When his contract was up in 1936, he moved to KYW and was heard nationally over the NBC Red network.

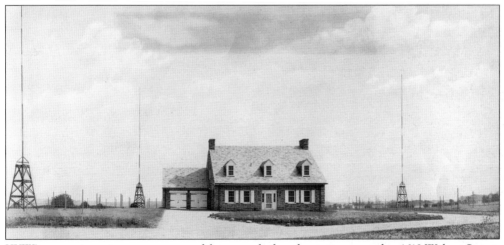

KYW's transmitter site was constructed four years before the station moved to 1619 Walnut Street. The site, located in Whitemarsh Township, Pennsylvania, included four steel pole towers mounted on wood bases. This antenna array required a large amount of ground; hence, the construction in what was then a sparsely populated community. (Courtesy of the Print and Picture Collection, Free Library of Philadelphia.)

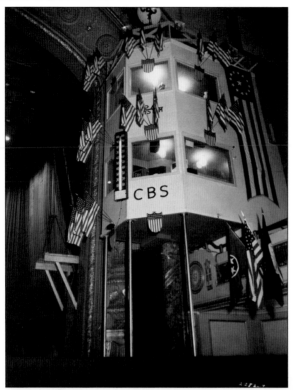

Radio began to affect the way politicians ran their campaigns as early as 1928. By the 1936 Democratic National Convention, which was held in Philadelphia, politicians had already adapted their speeches to the shorter attention span of radio listeners. The CBS nerve center included a "demonstrometer," which gauged the level of applause in the hall. (Courtesy of the Historical Society of Pennsylvania.)

Al Stevens (left) of the Mutual radio network utilized a portable broadcasting outfit to interview people on the street during the 1936 Democratic National Convention. The device functioned in a similar manner to today's wireless microphones, transmitting to a nearby base station for rebroadcast. (Courtesy of the Historical Society of Pennsylvania.)

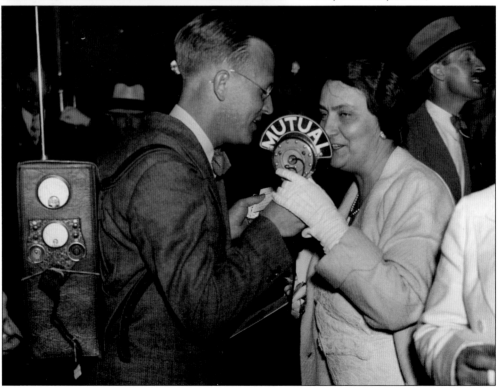

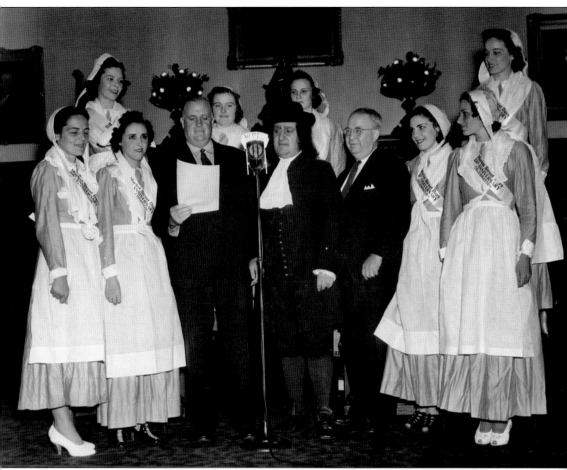

In 1938, Philadelphia celebrated the 250th anniversary of Market Street with a ceremony broadcast over WFIL. Here, eight Quaker maids flank, from left to right, Philadelphia's director of Public Works Martin McLaughlin, William Penn impersonator M.E. Gamble, and Ray Clark, member of the Committee of Market Street Day, as a proclamation is read. (Courtesy of the Historical Society of Pennsylvania.)

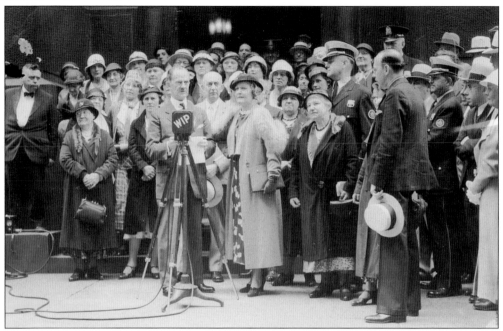

The Gimbel's WIP Home Makers Club, which was the oldest homemaking club program on the radio, celebrated its 11th anniversary in 1934. Philadelphia mayor J. Hampton Moore is seen here greeting 2,000 members of the club at the Navy Yard. Homemaker shows were created to appeal to housewives and introduce them to items for sale in the department stores. (Courtesy of the Historical Society of Pennsylvania.)

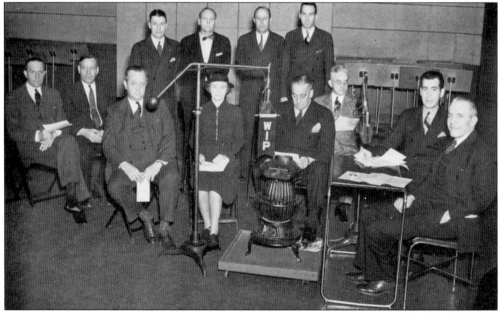

Pennsylvania Athletic Club officials discussed notable achievements by their athletes with Stoney McLinn (far right) on his WIP program *Hot Stove League of the Air*. McLinn was a popular Philadelphia sportswriter and Phillies sportscaster in the 1930s. (Courtesy of the Print and Picture Collection, Free Library of Philadelphia.)

32

Uncle WIP continued to be a popular children's show host on WIP well into the 1940s. Wayne Cody was one of the longest-running "uncles," as seen in this 1941 promotional booklet, *Uncle Wip's Radio Book*.

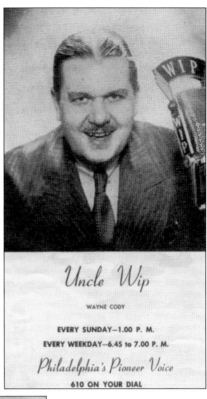

Uncle Wip

WAYNE CODY

EVERY SUNDAY—1.00 P. M.
EVERY WEEKDAY—6.45 to 7.00 P. M.

Philadelphia's Pioneer Voice

610 ON YOUR DIAL

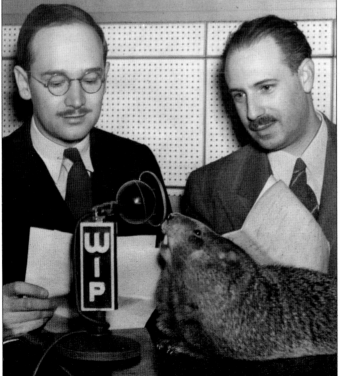

Roger Conant (left), curator of the Philadelphia Zoo, and Armand Spitz of the Franklin Institute interview the zoo's pet groundhog, Susie. The broadcast took place on Groundhog Day, February 2, 1942. Roger Conant was a herpetologist, author, and educator. Armand Spitz developed and marketed planetariums and also hosted radio programs about science and astronomy. (Courtesy of the Historical Society of Pennsylvania.)

WCAU program director Stan Lee Broza (left) welcomes famous raconteur and man-about-town Powers Gouraud back to his old nighttime show on October 15, 1941. Known as the Old Night Owl, Gouraud's Philadelphia broadcasting career spanned three decades. His other talents included songwriting, newspaper columnist, traveler, emcee, and sports enthusiast. (Courtesy of the Theatre Collection, Free Library of Philadelphia.)

In 1942, the WDAS broadcast of *Pop Johnson's Old Timers* was seen over television's WPTZ Channel 3 (now KYW-TV). Television was still very much an experimental medium at this time. WPTZ, one of the country's oldest television stations, was owned by the Philco Corporation, a Philadelphia manufacturer of radios and televisions, and had just received its commercial license the previous year. (Courtesy of the Historical Society of Pennsylvania.)

Mac McGuire (left) conducts an interview on the *Milkins Club* over WCAU in 1943. McGuire had a long history in Philadelphia broadcasting, with stints at WIP, KYW, WPEN, and various television shows on channel 3. He also had his own country and western group, Mac McGuire's Harmony Rangers, which recorded for multiple labels. (Courtesy of the Theatre Collection, Free Library of Philadelphia.)

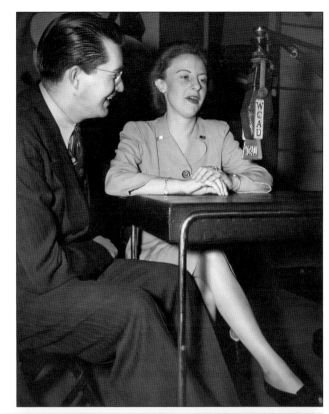

Marine sergeant Leon Little (left), retiring after 30 years service, made a guest appearance on Toni Winston's *Letter to a Soldier* program. The goal of Winston's weekly show of songs and chatter on KYW was to have listeners write at least one letter to a soldier. (Courtesy of the Theatre Collection, Free Library of Philadelphia.)

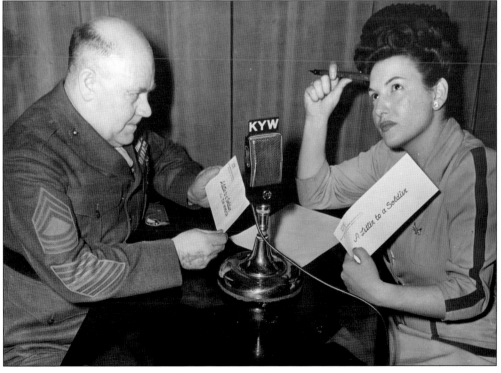

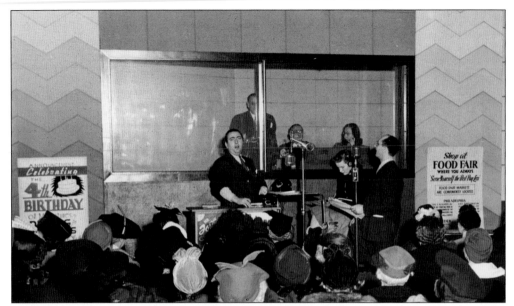

Howard Jones (center) is seen on the WIP program *Dialing for Dollars* in March 1943. By the 1950s, Jones had moved on to WFIL-TV (now WPVI) where he hosted a variety of programs. His most well-known role was as Happy the Clown, which he portrayed on Channel 6 from 1956 until his retirement in 1968. (Courtesy of the Theatre Collection, Free Library of Philadelphia.)

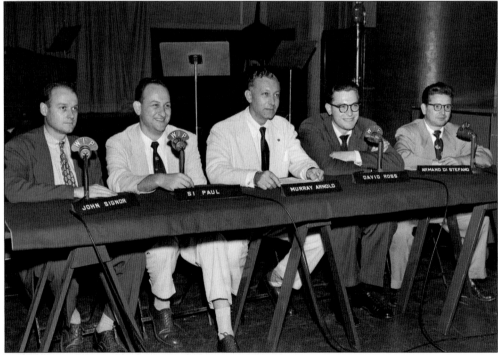

WIP gathered a group of record company public relations representatives for the panel program *Let's Talk Music.* Seen from left to right are John Signor of Victor, Si Paul of Capitol, moderator and WIP program director Murray Arnold, Dave Ross of Columbia, and Armand Di Stefano of Decca. (Courtesy of the Theatre Collection, Free Library of Philadelphia.)

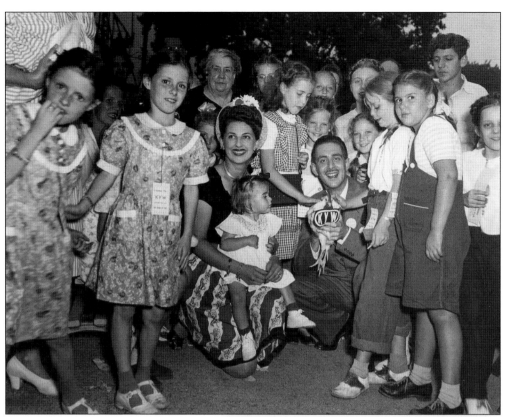

Peter Roberts, host of *KYW Morning Salute*, is seen holding the show mascot, Herman the Mad Rooster, at the second annual KYW Day at Willow Grove Park on August 21, 1946. Charlotte Dennis (center), host of *Babies Are Fun*, also helped greet the 30,000-plus listeners that showed up at the event. (Courtesy of the Theatre Collection, Free Library of Philadelphia.)

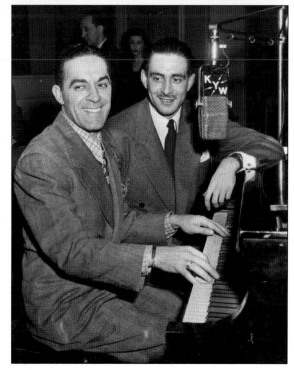

Bandleader Frankie Carle (left) appeared as a guest on KYW's *The Lunchtimers* with host Peter Roberts on January 30, 1947. The live show ran on KYW from 12:15 to 12:45 p.m. weekdays and included the full KYW studio orchestra, soloists, and nationally known guests. (Courtesy of the Theatre Collection, Free Library of Philadelphia.)

Donald Briggs (left) and Martin Bain are pictured rehearsing a scene on CBS's *FBI in War and Peace*, which ran from 1944 to 1958. This was one of the last radio dramas produced, and by 1960, virtually all remaining dramas on CBS and NBC were cancelled. (Courtesy of the Print and Picture Collection, Free Library of Philadelphia.)

Disc jockeys Jeanne and Andy Gainey hosted *At Home with the Gaineys* weekday mornings on WCAU, beginning January 20, 1947. WCAU was one of the last Philadelphia stations to start using hosts whose sole job was to spin records. As the golden age began to fade, stations depended more heavily on disc jockeys and less on live entertainers. (Courtesy of the Theatre Collection, Free Library of Philadelphia.)

Hal Moore, seen here in a 1949 promotional photograph, was a popular morning disc jockey on WCAU in the late 1940s and early 1950s. In addition to his radio work, Moore was a songwriter and hosted a show on WCAU-TV, where he played music and interviewed recording stars.

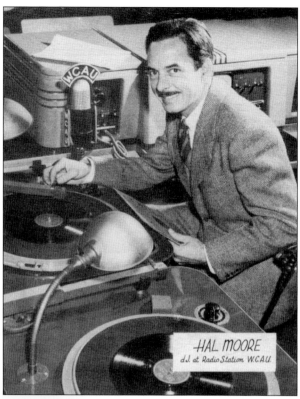

HAL MOORE
d.J. at Radio Station W.C.A.U.

Fran Lafferty (left) and Staats Cotsworth costarred in the CBS weekday soap opera *Marriage for Two* in 1948. That year, the 10 highest-rated daytime radio programs were all soap operas. The genre soon began transitioning to television, and by 1960, all the soaps had left radio. (Courtesy of the Theatre Collection, Free Library of Philadelphia.)

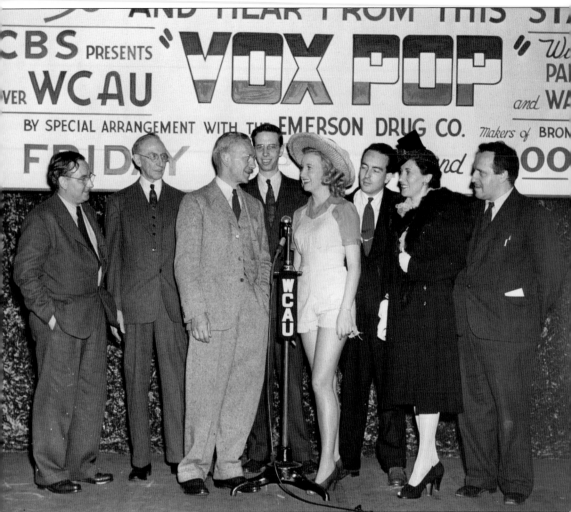

Some of the earliest radio quiz shows grew out of the person-on-the street interviews that host Parks Johnson conducted on the show *Vox Pop*, which launched in Houston in 1932. The program was picked up by the NBC network in 1935 and moved to CBS in 1939. Contestants were asked random questions and awarded a token prize for the correct answer. A special broadcast originated from the Philadelphia Victory Gardens Harvest Show on October 2, 1942, at Convention Hall. From left to right are Harry Murdock, WCAU publicity director; Charles Shoffner, WCAU farm reporter; Parks Johnson, host; Loretta Hannings, Miss Victory Gardens; J. Ervice, engineer; Russ Mulholland, announcer; Jean Colbert, WCAU women's editor; and Ray Stahl, engineer. (Courtesy of the Theatre Collection, Free Library of Philadelphia.)

The quiz show *Invitation to College* ran on KYW in 1946. Pictured here are, from left to right, George Friedland, president of Food Fair, sponsor of the program; Lorna J. Herman, student at Philadelphia Girl's High School; and Maj. Gen. J.A. Ulio, vice president of Food Fair. (Courtesy of the Theatre Collection, Free Library of Philadelphia.)

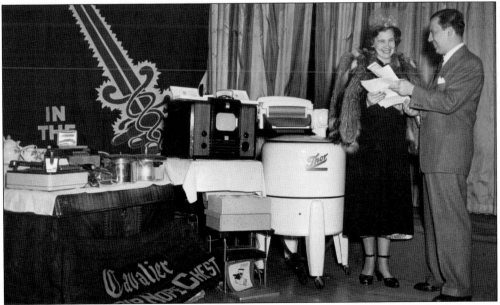

Frank Palumbo (right) is pictured presenting Mrs. Thomas White with over $3,000 in prizes on musical quiz show *Click Time*, which aired over WCAU in 1948. Restaurateur Palumbo owned a complex in South Philadelphia that included the Click Club, where early remote television broadcasts originated in the late 1940s. (Courtesy of the Theatre Collection, Free Library of Philadelphia.)

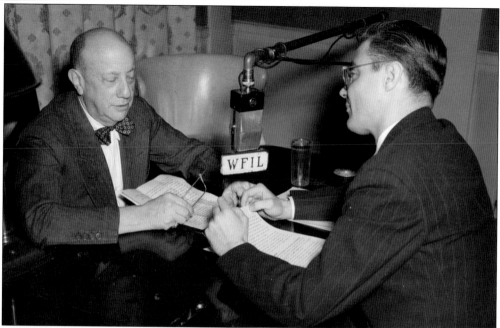

Leon Raines (left), chairman of the Pennsylvania State Athletic Commission, is interviewed by host Tom Moorehead on a WFIL sports show in 1944. Moorehead was later named sports director of WFIL radio and television and helped launch much of the station's earliest efforts in local televised sports coverage. (Courtesy of the Theatre Collection, Free Library of Philadelphia.)

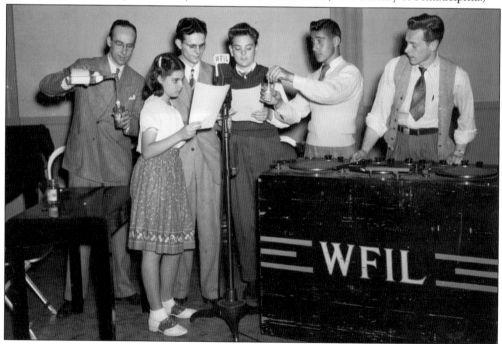

Skipper Dawes (left), educational director of WFIL, and a group of Philadelphia school students dramatize the discovery of the first ice cream soda in 1946. (Courtesy of Temple University Libraries, Urban Archives, Philadelphia, Pennsylvania.)

John B. Kennedy began his radio career at Newark, New Jersey, station WJZ in 1924. In 1948, the veteran broadcaster came to Philadelphia to host *The RCA Victor Eye-Witness News* program on WFIL. The main purpose of the show was to promote television, though it was done mainly through offhand comments about how great it would be to actually view the news stories being covered. (Courtesy of the Theatre Collection, Free Library of Philadelphia.)

WFIL

Your Station for

BING CROSBY
DON McNEILL
WALTER WINCHELL
TOM BRENEMAN
ABBOTT and COSTELLO
HENRY MORGAN
THE LONE RANGER
SLEEPY HOLLOW GANG
GANGBUSTERS
LeROY MILLER
THEATRE GUILD
PAUL WHITEMAN

WFIL had been an affiliate of the NBC Blue Network since the 1920s. In 1945, the network was renamed the American Broadcasting Company (ABC) and WFIL continued to be the main Philadelphia affiliate.

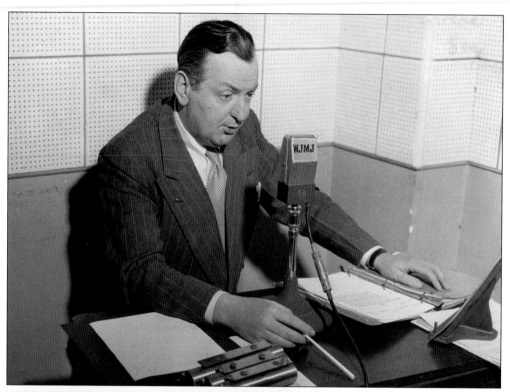

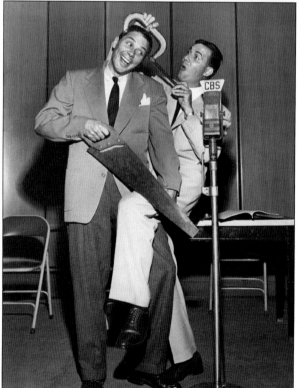

Former WDAS general manager Patrick Stanton founded Philadelphia station WJMJ (now WNWR) on December 26, 1946. The station featured religious and foreign language programming as well as Stanton's long-running *Irish Hour*. After selling the station in 1965, Stanton served as Mayor James Tate's press secretary from 1968 through 1971. (Courtesy of the Theatre Collection, Free Library of Philadelphia.)

Gene Rayburn (left) and Dee Finch hosted the zany and unpredictable *Rayburn and Finch* show on CBS in 1951. Rayburn had been a member of the first two-man team in morning radio with Jack Lescoulie on WNEW-AM in New York. Rayburn's most famous role was as host of the television game show *Match Game* in the 1970s. (Courtesy of the Theatre Collection, Free Library of Philadelphia.)

During a 1940s blackout, the beacon atop the Widener Building, which was located on WFIL's 250-foot tower, remained on by command (or lack thereof) of the US Army. According to reporters, it "shone like a light-ship in an otherwise darkened central city." (Courtesy of the Historical Society of Pennsylvania.)

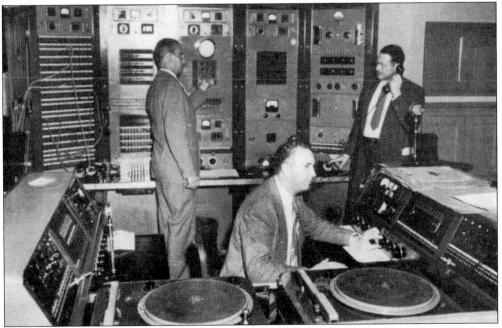

The WFIL control room located in the Widener Building is seen in this 1947 photograph. From left to right are Jack Schantz, Charles Coleman, and Chester Geise. In 1952, WFIL radio stations moved into expanded facilities at Forty-sixth and Market Streets, which already housed WFIL-TV. (Courtesy of John S. Flack Jr.)

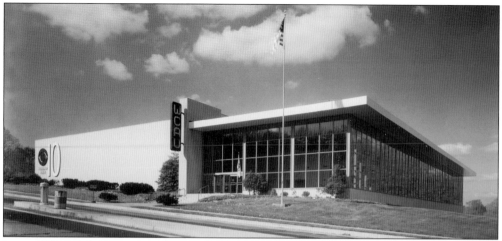

Just as WCAU's 1933 move to Chestnut Street coincided with the start of the golden age of radio, the station's 1952 move to spacious new studios in Bala Cynwyd coincided with the end of that period. The 100,000-square-foot structure was built foremost with television in mind, including one acre of television studio floor space. (Courtesy of the Lower Merion Historical Society.)

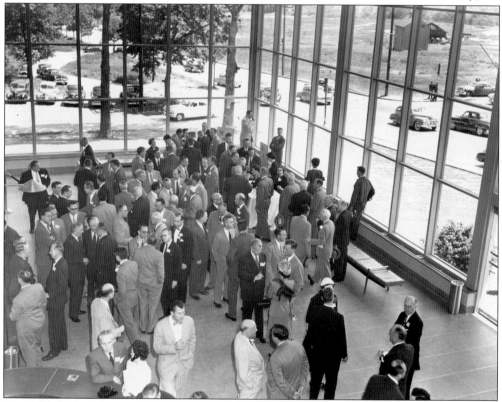

The dedication of the new WCAU Building just outside the city limits took place on May 27, 1952. Looking out the glass-enclosed lobby at the intersection of City Line and Monument Avenues reveals how undeveloped the area was at that time. Over the next 30 years, many radio stations would end up moving to this suburban vicinity. (Courtesy of Temple University Libraries, Urban Archives, Philadelphia, Pennsylvania.)

NEW TIME

THE TALK OF PHILADELPHIA
ED HARVEY

1:00-3:00 PM on WCAU RADIO for the most famous meeting place since the Algonquin Roundtable. Meet people like these: Josh Logan, Harold Lloyd, Victor Borge, Drew Pearson, prominent doctors, lawyers, civic leaders, authors. Talk to them, too; it's as simple as calling MO 7-0500.

Scintillating . . . exhilarating . . . fascinating . . . 1:00-3:00 PM.

NEW REPORTING CONCEPT

Audiences that have seen and heard Taylor Grant, will find **NEWS CONFERENCE** at 12:15 PM a refreshing daily forum on topical and local matters of importance. Add George Lord's acute, clear-cut reporting and you have a news team without equal.

At 5-7 PM daily, Taylor Grant is the editor of a most exciting concept in radio news. The top stories of the day—no matter the subject—will be the lead-off feature of EVENING EDITION and all news will be covered in depth.

The EVENING EDITION team, unmatched in experience, news perception, and judgment, includes George Lord, Bill Campbell, Mike Stanley, John Facenda, J. A. Livingston and Lowell Thomas + Krick Weather Central Reports and two WCAU Radio GO PATROL helicopter teams.

OPINIONATED BUT STILL LOVABLE BOB MENEFEE

It's still 6-10 AM, Monday through Friday, and now 8:15-Noon Saturday, for Bob and he's still just the way you like (or dislike) him.

trenchant • veracious
gregarious • intrepid
inexorable • audacious

(add your own words— you know lovable Bob as well as we do)
6 AM, then, for one of the most colorful fellows around.

Taylor Grant George Lord

After the golden age began to fade, WCAU concentrated on news and talk shows, including the ambitious *Evening Edition*. The show resembled a radio version of a daily newspaper, with news and features delivered by a team of reporters covering a wide variety of subjects.

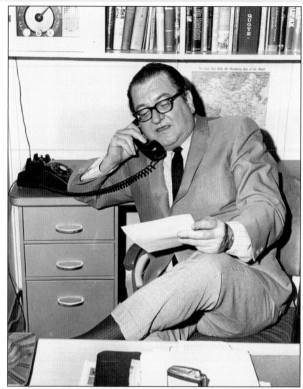

Bob Menefee worked the morning drive on WCAU in the mid-1960s after spending time at WIP. A longtime broadcaster, Menefee worked at 11 other stations before arriving at WCAU. In addition to radio announcing and spinning records, he narrowly lost the Democratic primary for congressman from Virginia's sixth district in 1948. (Courtesy of Temple University Libraries, Urban Archives, Philadelphia, Pennsylvania.)

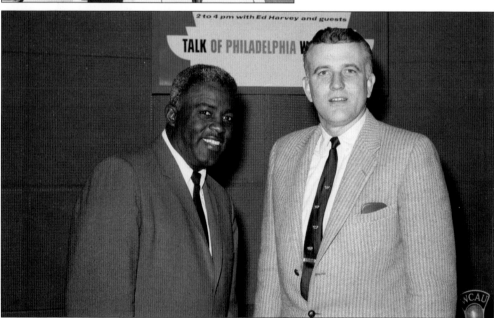

Ed Harvey (right), seen here with civil rights icon and baseball superstar Jackie Robinson, joined WCAU-AM (now WPHT) in the early 1950s and remained at the station for more than 20 years. Harvey was a pioneering talk radio host at the station and interviewed numerous politicians and celebrities during his long career. (Courtesy of the Theatre Collection, Free Library of Philadelphia.)

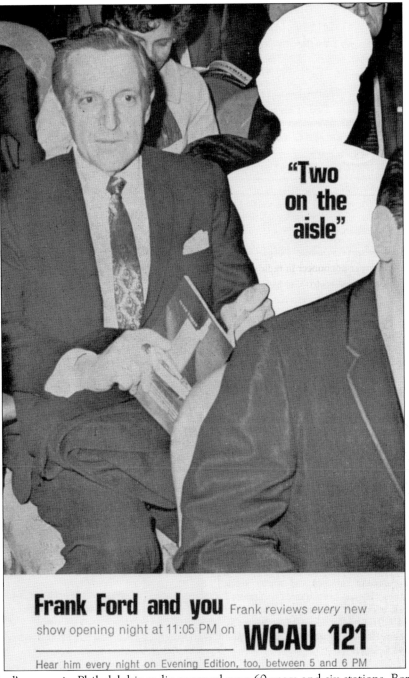

"Two on the aisle"

Frank Ford and you Frank reviews *every* new show opening night at 11:05 PM on **WCAU 121**

Hear him every night on Evening Edition, too, between 5 and 6 PM

Frank Ford's career in Philadelphia radio spanned over 60 years and six stations. Born Eddie Felbin, Ford was well known for his numerous talk shows and claimed that he was the first one in the country to do two-way talk on the radio, where the listeners could hear the caller as well as the host on the air. In the 1980s, he owned talk station WDVT (now WURD) where he also hosted a daily program. His final show was on FM talk station WWDB in 2000. Ford was the husband of Philadelphia district attorney Lynne Abraham. Frank Ford passed away at the age of 92 on March 3, 2009.

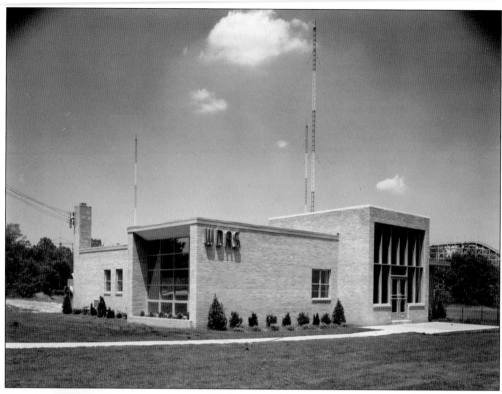

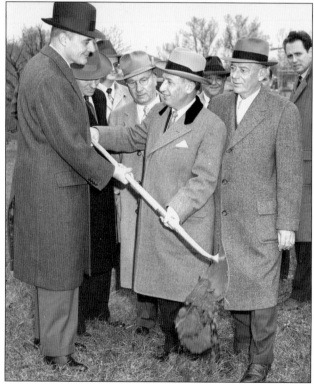

The WDAS studios and towers were built on the ground formerly occupied by Woodside Park, an amusement park in West Philadelphia that closed in 1955. The WDAS Building was located on Edgely Drive near Belmont Avenue in Fairmount Park for over 40 years. (Courtesy of the Athenaeum of Philadelphia.)

Philadelphia mayor Richardson Dilworth and WDAS president Max M. Leon hold a shovel during the ground-breaking ceremonies for the WDAS Building on Edgely Drive. Seen from left to right are Mayor Dilworth, unidentified, Bill Vogt, unidentified, Leon, Louis Palens, unidentified, and Bob Klein. (Courtesy of the Bob Klein Archives and WDASHistory.org.)

Radio pioneers huddle for a discussion at the 35th anniversary
party of WFIL in 1957. Seen from left to right are Harold
Simonds, who had been with the station since its inception as
WFI in 1922; Ednyfed Lewis, general manager of WFI until 1934;
Phil Sheridan, popular early morning disc jockey on WFIL;
and media mogul Walter H. Annenberg, president of Triangle
Publications and owner of WFIL. Simonds and Lewis participated
in the first broadcast heard over WFI on March 18, 1922. (Above,
courtesy of the Theatre Collection, Free Library of Philadelphia.)

Joe McCauley was a WIP radio personality for 26 consecutive years, beginning as host of the all-night *Dawn Patrol* in 1942. McCauley became the morning drive host in 1954 and is best remembered as the "morning mayor" who helped Philadelphians begin their day.

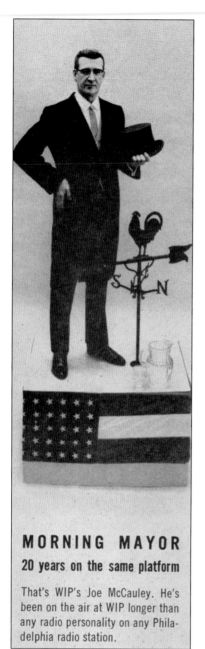

MORNING MAYOR
20 years on the same platform

That's WIP's Joe McCauley. He's been on the air at WIP longer than any radio personality on any Philadelphia radio station.

Jack O'Reilly, former NBC Page, had a long history in radio, with stints at WNEW and WOR in New York, as well as KYW, WPEN, WPBS, WYSP, WWDB, and WIOQ in Philadelphia. At WPEN, O'Reilly was a sportscaster and later the morning show announcer, with his jingle "Oh Really? No! O'Reilly."

Three

THE ROCK MUSIC ERA

When national network radio faded at the close of the golden age, local stations were forced to come up with their own programming to fill the void. An inexpensive route that many stations chose was to hire a disc jockey to play popular records. In the early 1950s, popular records meant the likes of Patti Page, Perry Como, and Rosemary Clooney, which is exactly what stations like WPEN and WIP were playing. This was the type of relatively tame music that scores of teenagers danced to on radio shows such as the *950 Club*.

At the same time, just up the dial, there was a more rhythmic tune on WDAS and WHAT. It was the sound of rhythm and blues, intended for a black audience. Unexpectedly, white teenagers quickly became attracted to this music, partly because the sleepy ballads of the day did not lend themselves to energetic dancing. Hy Lit, who began his career at WHAT in 1954 as the station's only white disc jockey, soon garnered a tremendous integrated following by playing the songs that teens wanted to hear.

Rock and roll evolved in part from rhythm and blues, sometimes rebranding the latter's songs for a white audience. In other parts of the country, outrage over rock and roll was tinged with racism over its black roots. Philadelphia, however, was a city with fewer racial divisions when it came to music, and rock was a shared experience among blacks, whites, Italians, and others. Philadelphia was also a city where hits were being made, as street-corner stars like Frankie Avalon, Fabian, Chubby Checker, and Bobby Rydell added an innate local flavor to their music.

In Philadelphia, WIBG (pronounced "wibbage") had a monopoly on the mainstream Top 40 format from the late 1950s until 1966. During this time, the station was incredibly successful and still holds a special place in the memories of the city's baby boomers. At one point, Hy Lit commanded a 71 share—71 percent of the radio audience was listening to his show on WIBG. No local radio programming has dominated the airwaves to such a degree since.

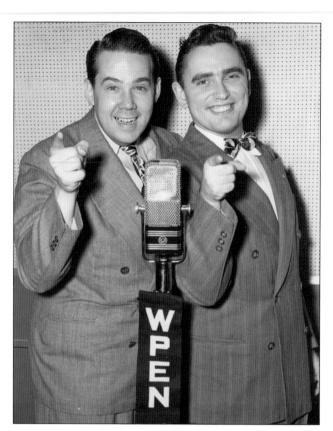

Joe Grady (left) and Ed Hurst were the hosts of the *950 Club* on WPEN from 1946 to 1955 and again from 1980 to 1988. Teenagers from all over Philadelphia came to dance and watch interviews with recording stars in a studio/restaurant called the William Penn Room at 2212 Walnut Street. Even though the music predated rock and roll, Dick Clark has credited Grady and Hurst as being the model for American Bandstand, the epitome of televised rock and roll. (Courtesy of the Theatre Collection, Free Library of Philadelphia.)

This matchbook cover shows Cal Milner and Larry Brown, who hosted the *950 Club* on WPEN after Grady and Hurst left in 1955.

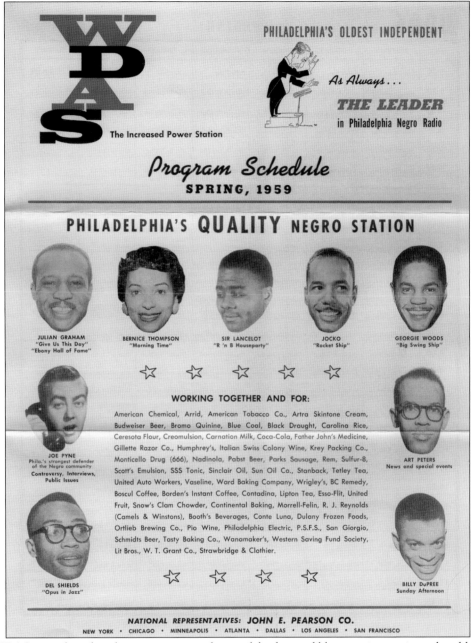

W D A S

The Increased Power Station

PHILADELPHIA'S OLDEST INDEPENDENT

As Always...

THE LEADER
in Philadelphia Negro Radio

Program Schedule
SPRING, 1959

PHILADELPHIA'S QUALITY NEGRO STATION

JULIAN GRAHAM
"Give Us This Day"
"Ebony Hall of Fame"

BERNICE THOMPSON
"Morning Time"

SIR LANCELOT
"R 'n B Houseparty"

JOCKO
"Rocket Ship"

GEORGIE WOODS
"Big Swing Ship"

☆ ☆ ☆ ☆ ☆

WORKING TOGETHER AND FOR:

American Chemical, Arrid, American Tobacco Co., Artra Skintone Cream, Budweiser Beer, Bromo Quinine, Blue Coal, Black Draught, Carolina Rice, Ceresota Flour, Creomulsion, Carnation Milk, Coca-Cola, Father John's Medicine, Gillette Razor Co., Humphrey's, Italian Swiss Colony Wine, Krey Packing Co., Monticello Drug (666), Nadinola, Pabst Beer, Parks Sausage, Rem, Sulfur-8, Scott's Emulsion, SSS Tonic, Sinclair Oil, Sun Oil Co., Stanback, Tetley Tea, United Auto Workers, Vaseline, Ward Baking Company, Wrigley's, BC Remedy, Boscul Coffee, Borden's Instant Coffee, Contadina, Lipton Tea, Esso-Flit, United Fruit, Snow's Clam Chowder, Continental Baking, Morrell-Felin, R. J. Reynolds (Camels & Winstons), Booth's Beverages, Conte Luna, Dulany Frozen Foods, Ortlieb Brewing Co., Pio Wine, Philadelphia Electric, P.S.F.S., San Giorgio, Schmidts Beer, Tasty Baking Co., Wanamaker's, Western Saving Fund Society, Lit Bros., W. T. Grant Co., Strawbridge & Clothier.

JOE PYNE
Phila.'s strongest defender of the Negro community
Controversy, Interviews, Public Issues

ART PETERS
News and special events

DEL SHIELDS
"Opus in Jazz"

☆ ☆ ☆ ☆

BILLY DuPREE
Sunday Afternoon

NATIONAL REPRESENTATIVES: JOHN E. PEARSON CO.
NEW YORK · CHICAGO · MINNEAPOLIS · ATLANTA · DALLAS · LOS ANGELES · SAN FRANCISCO

WDAS contributed to the enormous popularity of rhythm and blues music at a time when black artists could not get airplay on mainstream stations. WDAS was one of the first stations in the country to play records by Sam Cooke, Aretha Franklin, the Beatles, Marvin Gaye, Buddy Holly, and Stevie Wonder. In addition to breaking new rhythm and blues and soul hits, WDAS established a full-service news department that provided coverage of every major civil rights breakthrough. Dr. Martin Luther King Jr.'s confidant, ambassador Andrew Young, said of WDAS: "To our knowledge there is no station in America that has worked harder, longer and with more dedication for Black people than WDAS in Philadelphia." (Courtesy of the Bob Klein Archive and WDASHistory.org.)

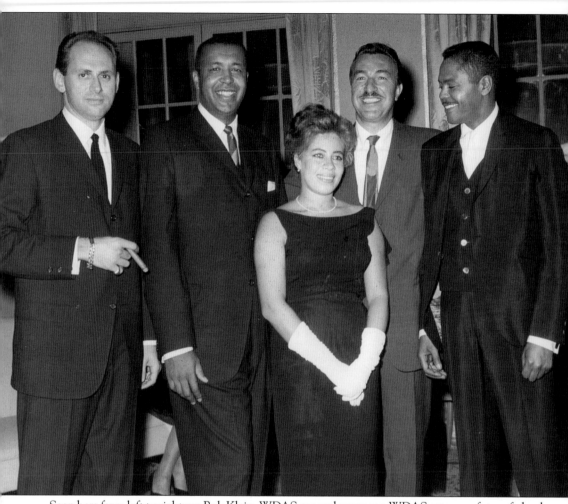

Seen here from left to right are Bob Klein, WDAS general manager; WDAS attorney, future federal judge, and noted author A. Leon Higginbotham; Jeanne Higginbotham; civil rights powerhouse Congressman Adam Clayton Powell Jr.; and disc jockey Georgie Woods around 1958. Quoted in the *Congressional Record*, historian Wynne Alexander writes of the role WDAS played in the history of the civil rights movement: "WDAS was both a participant and a leader in perhaps the world's greatest multi-cultural, multi-racial victory over entrenched oppression. Under tremendous pressure from all sides, emerges this extraordinary example of Blacks and Whites working together for Justice. Working together on behalf of Freedom, to benefit all people, to free a nation, an effort that can serve as a beacon throughout the world. An example of what can be done when the humanity and beauty of differing cultures matter more than anything else." (Courtesy of the Bob Klein Archive and WDASHistory.org.)

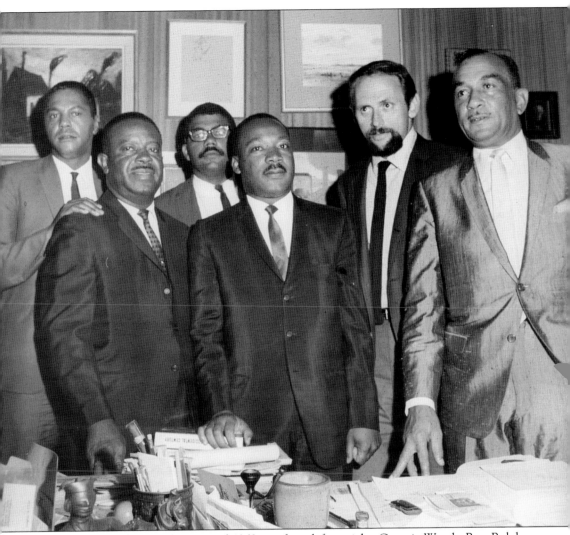

Meeting at the WDAS studios around 1963 are, from left to right, Georgie Woods; Rev. Ralph Abernathy, SCLC; Ed Bradley, WDAS newsman and later of CBS News; Dr. Martin Luther King Jr.; WDAS general manager Bob Klein; and Philadelphia NAACP president Cecil Moore, Esq. WDAS was an early supporter of Dr. King and provided extensive coverage of his civil rights activities. WDAS paid for 13 busloads of listeners to attend the 1963 March on Washington and included a WDAS staffer on each bus to act as captain. After Dr. King's assassination, the programming efforts at WDAS were credited with keeping Philadelphia calm while other cities reacted with violence. (Courtesy of the Bob Klein Archive and WDASHistory.org.)

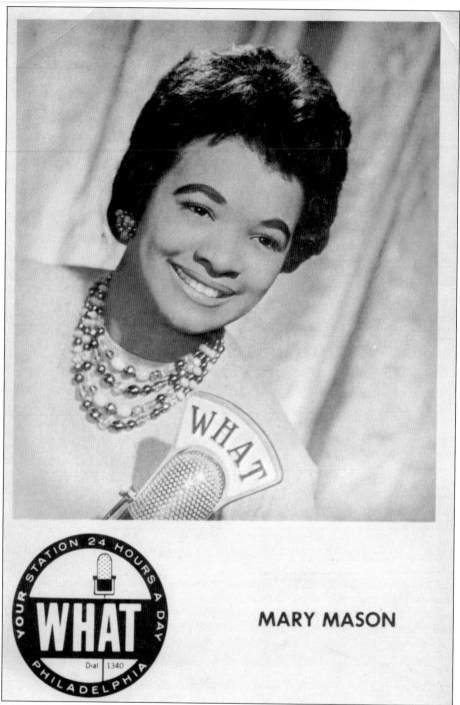

MARY MASON

WHAT was another influential soul and rhythm and blues station in the 1950s and 1960s, with legendary disc jockeys such as Sonny Hopson, Mary Mason, Kae Williams, and Hy Lit. Mary Mason began her broadcast career as a gospel music host on WHAT in 1958. Her first talk show, *Mornings with Mary,* debuted on WHAT in 1970. Mason and her influential talk show remained at the station until it was sold in 2007.

First in Philadelphia

The first program on WIBG aired April 19, 1925, from St. Paul's Episcopal Church in Elkins Park, Pennsylvania (legend has it WIBG stood for "I Believe in God"). Rock and roll arrived at the station in 1956, courtesy of disc jockey Joe Niagara, who played some of the earliest rock music at the station. In 1958, WIBG programmed rock and roll 24 hours a day, the first station in Philadelphia to do so. For the next eight years, WIBG had the format all to itself and boasted huge ratings. Initially, the disc jockeys had a good deal of influence over choosing the songs that were played. Record company reps, who often hung around the station promoting their acts, were aware of this and were known to offer incentives to get their acts airplay. The illegal practice of payment for airplay of music was called payola and hastened the removal of the disc jockeys from the song selection process at many stations.

Hy Lit was one of the city's first well-known disc jockeys of the rock era. In addition to working at WHAT, Lit also spent a year at WRCV (now KYW) before landing at WIBG in 1957. His frequent record hops, one of which is pictured here, were met with sell-out crowds across the city. (Courtesy of HyLitRadio.com.)

Hy Lit is pictured here at the WIBG studios in the mid-1960s. In addition to his ability to pick the hits, Lit was also known for his hip expressions. He had a vocabulary of his own when communicating with teens of the day. "For all my carrot tops, lollipops, and extremely delicate gum drops. It's Hyski 'O Roonie McVouti 'O Zoot!" (Courtesy of HyLitRadio.com.)

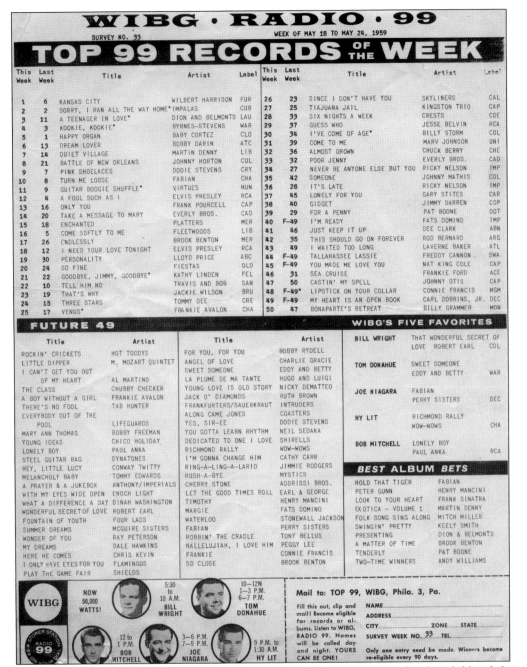

Teenagers listening to WIBG considered the weekly Wibbage survey to be their bible while following along with the top songs of the day. By 1963, the station was printing 105,000 sheets per week in its own print shop. The survey was based on locally and nationally reported record sales and distributed to hundreds of retail outlets. (Courtesy of the estate of Bonnie Brill.)

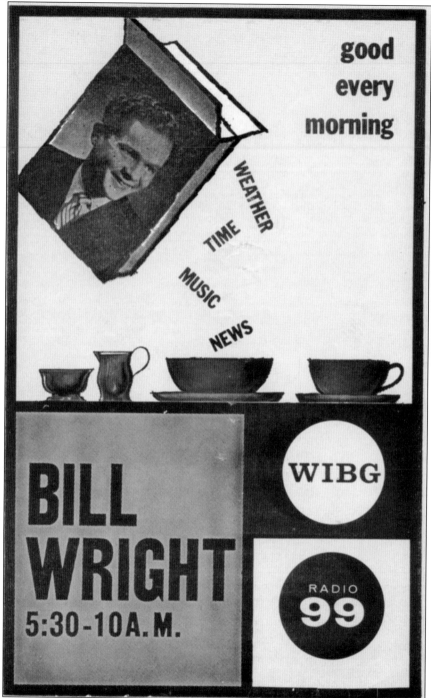

good
every
morning

WEATHER
TIME
MUSIC
NEWS

BILL
WRIGHT
5:30-10A. M.

WIBG

RADIO
99

Bill Wright Sr. started his career in Birmingham, Alabama, at WSGN and WBRC before arriving at WIBG in 1957, where he would spend the next 11 years. Wright's WIBG morning show was so popular that typically more than half of all the people listening to radio in Philadelphia at that time were listening to his show. This feat effectively makes Bill Wright Sr. the most popular morning show host in the history of Philadelphia radio. (Courtesy of Ada Brill.)

Hy Lit hosted the television dance show *Block Party* in the back lot of Channel 10 in 1957. Philadelphia has a rich legacy regarding teen television dance shows, largely due to the popularity of American Bandstand. All told, the city had more of these shows than any other market in the country. (Courtesy of HyLitRadio.com.)

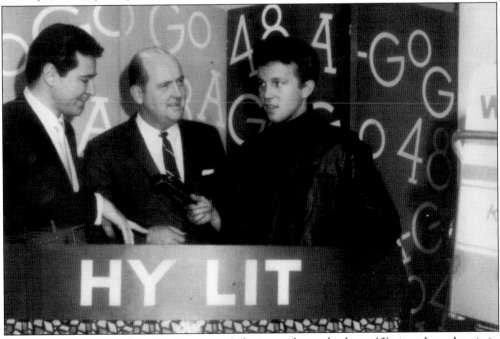

In 1965, three independent UHF stations (television channels above 13) signed on the air in Philadelphia looking to fill airtime with inexpensive original programming. Many of the city's disc jockeys were called into action to host dance shows, such as Hy Lit's *48 A-GoGo* on WKBS-TV. This photograph from the show's first season shows Hy Lit (left) with singer Bobby Vinton (right). (Courtesy of HyLitRadio.com.)

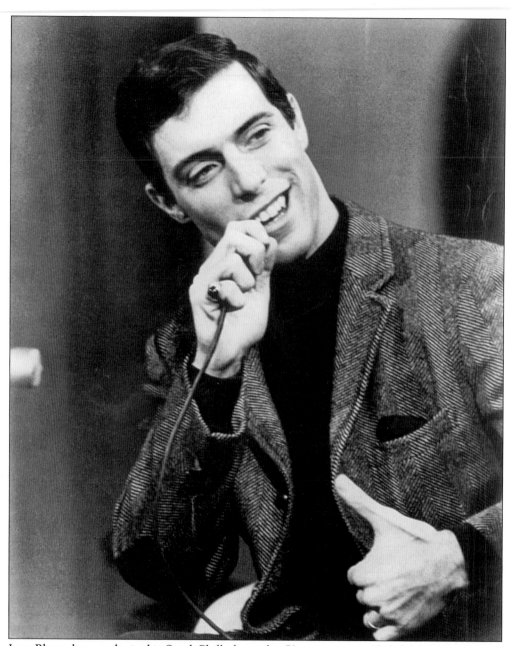

Jerry Blavat, born and raised in South Philly, began his 50-year career in Philadelphia broadcasting as a dancer on the original *Bandstand*. His radio career began in 1960 at WCAM in Camden, New Jersey. Blavat purchased his own airtime and secured his own sponsors, so he was free to play whatever he wanted. One snowy night, he took a stack of his own records to the station and played them all night to a tremendous teenage response. Soon, he was known as the "Geator with the Heater" with a lexicon all his own that seemingly only teens of the day could decipher. In 1965, he produced and hosted *The Discophonic Scene* on WCAU-TV, which later aired nationwide in 40 markets. In the 1990s, he ran oldies station WPGR (now WNWR), which was known as "Geator Gold Radio."(Courtesy of Jerry Blavat.)

In the early 1960s, Jerry Blavat was king of the record hop disc jockeys in Philadelphia, regularly pulling four hops per weekend and drawing some 6,000 youngsters at $1 a head. Blavat was known to rent a helicopter to efficiently and spectacularly transport himself from hop to hop. (Both, courtesy of Jerry Blavat.)

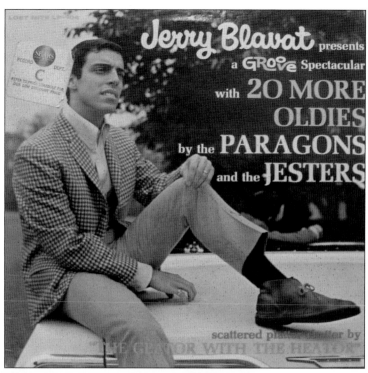

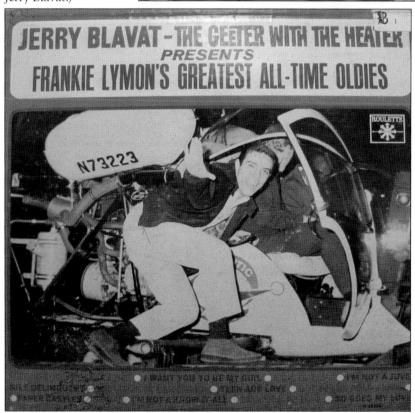

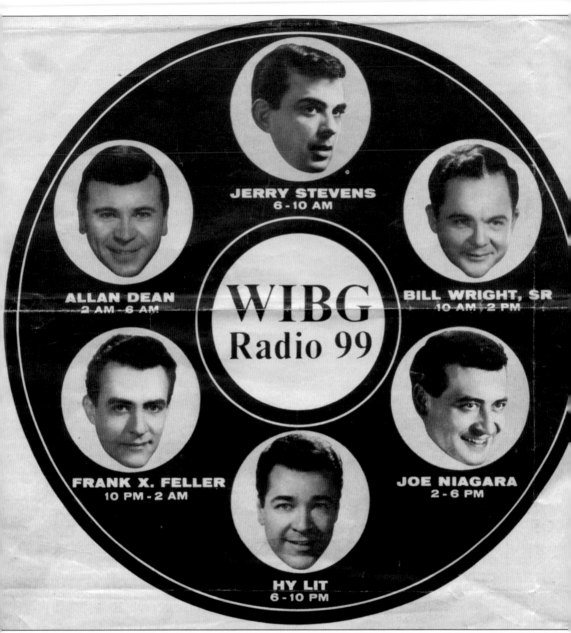

The 1966 lineup of WIBG jocks included some of the biggest names in Philadelphia radio. They were known as the Wibbage Good Guys, and each one had a distinctive on-air personality and were regarded as celebrities in their own right by their rapt teenage audience. (Courtesy of HyLitRadio.com.)

Joe Niagara, born as Joseph Nigro Jr. in South Philly, was best known for his time at WIBG and WPEN, but he also enjoyed stints at WFIL, WIFI-FM, and WCAU AM and FM. Niagara retired from WPEN in 2002 and passed away in 2004.

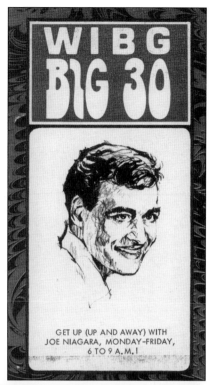

WIBG legends Joe Niagara (left) and Hy Lit (right) are seen with *The Man From U.N.C.L.E.* star David McCallum on June 25, 1969. (Courtesy of HyLitRadio.com.)

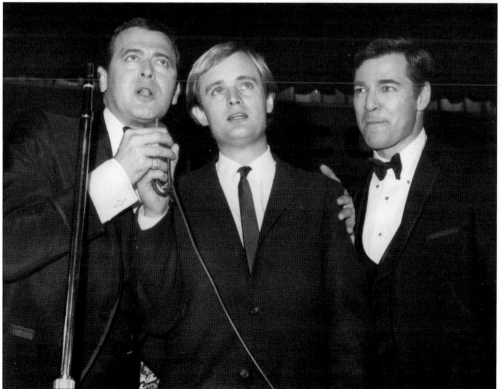

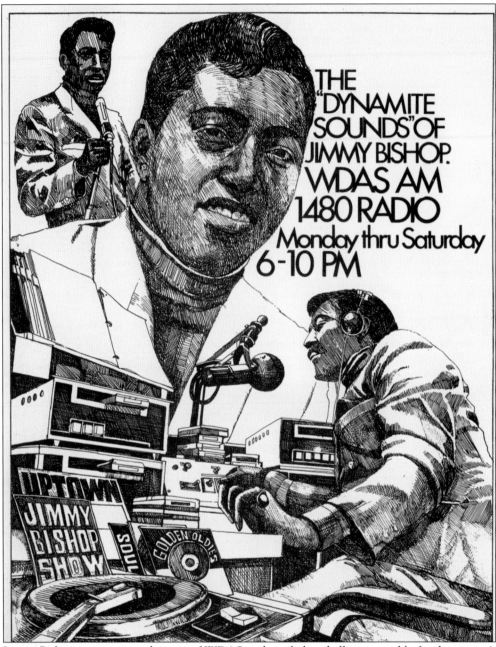

Jimmy Bishop was program director of WDAS and single-handedly responsible for the station's sound and position as a major musical force in the industry. Program directors from all over the country would call Bishop on weekends to find out what he was adding to the playlist on Monday—they trusted his ears over their own. Jimmy Bishop eventually moved from radio into the music industry, first at Philadelphia International Records and then at April Blackwood Music. (Courtesy of the Bob Klein Archive and WDASHistory.org.)

This photography shoot outtake features radio innovator Bob Klein joining the WDAS-AM jocks. Pictured from left to right are Johhny-O, Georgie Woods, Larry Daley, program director Jimmy Bishop, WDAS general manager Bob Klein, Joe "Butterball" Tamburro, and Mr. Freeze. (Courtesy of the Bob Klein Archive and WDASHistory.org.)

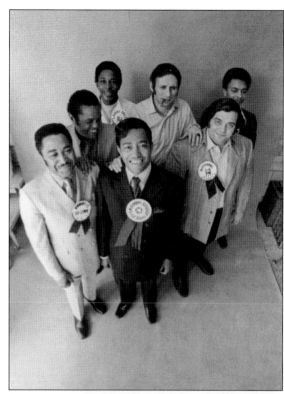

WDAS CEO and Philadelphia Grand Opera Company president Max M. Leon presents a proclamation to the Temptations on March 7, 1969. A joy and commitment to music fueled much of Leon's lifelong endeavors and aspirations. This event brought two of his musical worlds together. Seen at the award ceremony are, from left to right, Melvin Franklin, Eddie Kendricks, Dennis Edwards, Max M. Leon, Paul Williams, and Otis Williams. (Courtesy of the Bob Klein Archive and WDASHistory.org.)

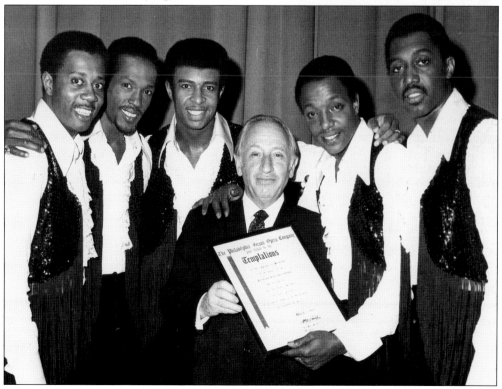

JAY COOK

JIM NETTLETON

GEORGE MICHAEL

On September 18, 1966, WFIL launched a new Top 40 format called the Pop Explosion as a direct challenge to market leader WIBG. WFIL's disc jockeys were known as the boss jocks and included some of the most talented and sought-after personalities in the business. With this new format that featured a tighter, slicker presentation of hit music, it took less than a year for WFIL

DISC JOCKEYS

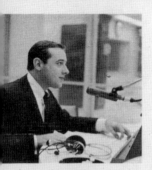

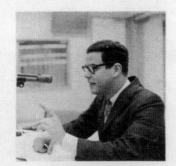

DAVE PARKS

FRANK SMITH

CHUCK BROWNING

EXPLOSiON

to dethrone WIBG as the city's top pop station. It also helped that WFIL initially played three to four more songs per hour and fewer commercials than WIBG. WFIL quickly became the prototype for successful Top 40 radio stations across the country.

MONDAY, JULY 22, 1968

MUSIC POWER

WFIL FAMOUS 56

Although WFIL and WIBG were both Top 40 stations, there were some significant differences in the music played on each station. WIBG had a longer playlist of the top 99 current records, while WFIL played a shorter list of about 30 current songs. WFIL was also a more research-based format focusing more on the top hits.

WIBG BIG 30

WIBG SALUTES

THE SOUNDS OF THE SIXTIES!

THIS WEEKEND, DIG

THE GOLDEN GREATS FROM 60 TO 68

STARTING AT NOON, FRIDAY ON

THE BIG 99 WIBG

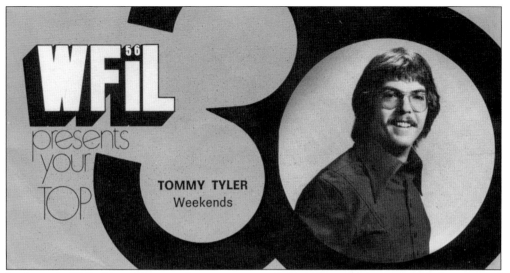

In the early 1970s, Tom Tyler was the swingman at WFIL who worked weekend shifts and filled in as needed. In addition, Tyler was the voice heard on all of the half-hour station identifications and most contest promos. (Courtesy of Dave Shayer.)

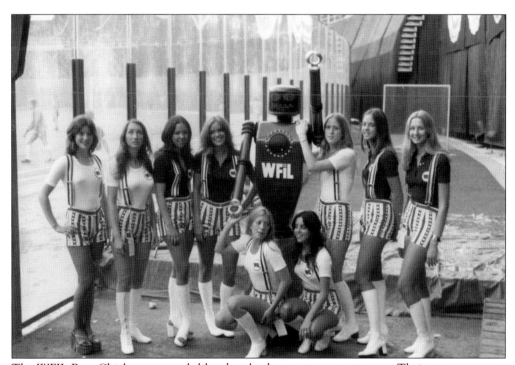

The WFIL Boss Chicks were much like cheerleaders are to a sports team. Their appearances at promotional events were very popular with fans. They are seen here with the station's robot, Mr. WIFFIL, in the bullpen at Veteran's Stadium in 1973. (Courtesy of Randy Roberts.)

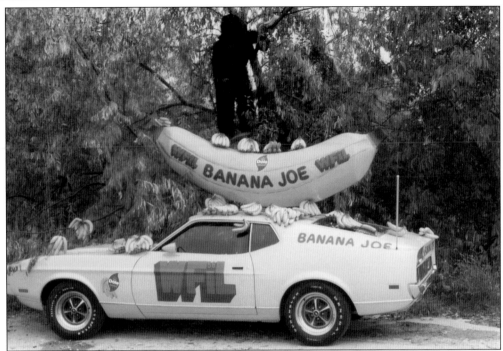

"Banana" Joe Montione cruised to promotional events in the WFIL Bananamobile and was supplied with unlimited bananas by Dole. This was just one of the many vehicles in the formidable WFIL fleet that included three double-decker busses, a mobile studio, and a mobile bandstand. (Courtesy of Randy Roberts.)

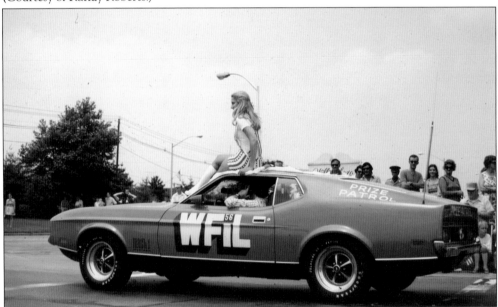

The WFIL Prize Patrol was one of the station's most popular contests. Red and green mustangs cruised area roads and patrollers read the license plates of random cars on the air. If the driver indicated he or she was listening to WFIL, by waving or honking their horn, they would pull over and win a prize. (Photograph by John Tomenga.)

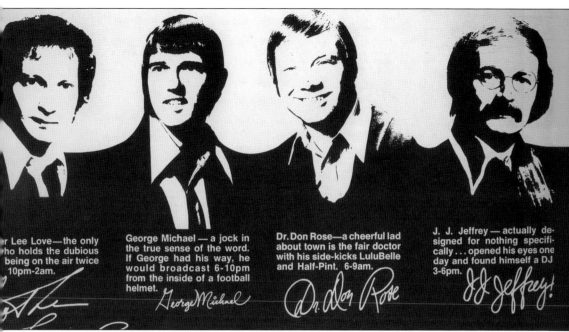

r Lee Love—the only
ho holds the dubious
being on the air twice
10pm-2am.

George Michael — a jock in the true sense of the word. If George had his way, he would broadcast 6-10pm from the inside of a football helmet.

Dr. Don Rose—a cheerful lad about town is the fair doctor with his side-kicks LuluBelle and Half-Pint. 6-9am.

J. J. Jeffrey — actually designed for nothing specifically... opened his eyes one day and found himself a DJ 3-6pm.

Some of the personalities from the later years of WFIL's Top 40 era included Alan "Brother Lee Love" Smith, George Michael, Dr. Don Rose, and J.J. Jeffrey (also known as Joseph N. Jeffrey Jr.). George Michael left WFIL in 1974 to replace Bruce "Cousin Brucie" Morrow on WABC in New York and later became well known as a television sportscaster and host of *The Sports Machine*. Dr. Don Rose hosted a popular morning show on WFIL. By 1980, all the boss jocks had left WFIL and the station was playing a softer, more adult-oriented format.

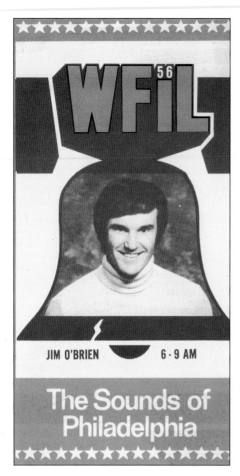

WFIL 56

JIM O'BRIEN 6-9 AM

The Sounds of
Philadelphia

Jim O'Brien arrived in Philadelphia as a disc jockey on WFIL in 1970. When Dr. Don Rose left the station in 1973, O'Brien took over the morning drive spot. On television, O'Brien hosted the programs *Dialing for Dollars* and *Prime Time* for WPVI-TV Channel 6. He is best remembered for his work on WPVI-TV's Action News as an anchor and beloved weatherman in the 1970s and early 1980s. His unique weather segments often included references to "bad humdingers from the south," and Casa Grande, a city in Arizona. Jim O'Brien died in a skydiving accident on September 25, 1983. (Left, courtesy John S. Flack Jr.; below, courtesy Randy Roberts.)

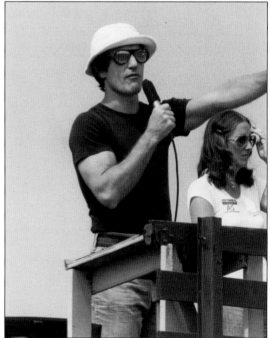

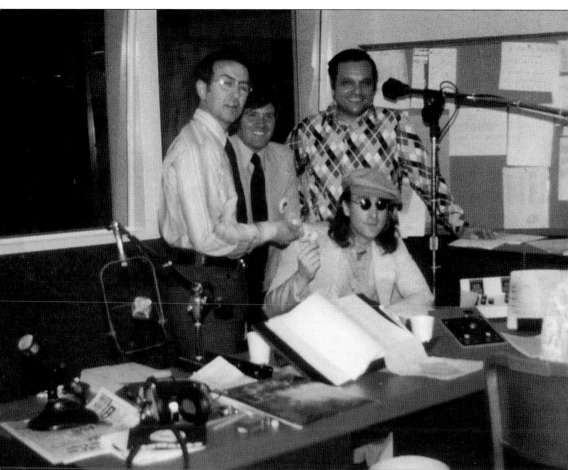

The WFIL *Helping Hand Marathon* ran from May 16 to 18 in 1975 and featured John Lennon as a special guest star. The event took place at the WPVI/WFIL studios and parking lot at 4100 City Avenue. The goal was to raise $110,000 to be divided among multiple charities that benefited handicapped children. Lennon spent the entire weekend in Philadelphia answering phones, taking pledges, meeting the fans, and speaking on the air. He even appeared on Channel 6 as a guest weatherman. Lennon is seen here in the WFIL studios with, from left to right, Jim DeCaro, general manager; Jay Cook, program director; and Gene Vassal, general sales manager. (Courtesy of Randy Roberts.)

The WRCP studios were located at 2043 Locust Street in Center City Philadelphia from the late 1960s through the early 1980s. Seen here in 1972, the building was nicknamed the "Rittenhouse Ranch" because of its proximity to Rittenhouse Square and the fact that the station was playing a country music format. (Courtesy of Temple University Libraries, Urban Archives, Philadelphia, Pennsylvania.)

In 1975, boxing matches were broadcast on Philadelphia airwaves after nearly a 20-year absence. WRCP boxing announcers Del Parks (left) and Skip Clayton provided blow-by-blow commentary from ringside at the Spectrum for up to six bouts per night. (Courtesy of Temple University Libraries, Urban Archives, Philadelphia, Pennsylvania.)

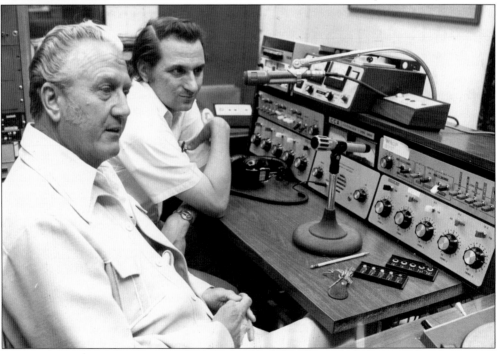

In the mid-1970s, WIP played a contemporary mix of music aimed at a slightly older audience than WFIL and WIBG. The station used a full-service approach that included a heavy emphasis on news and sports. Popular morning host Ken Garland is pictured here (left) in the 1972 Thanksgiving Day Parade. (Courtesy of PhillyHistory.org, a project of the Philadelphia Department of Records.)

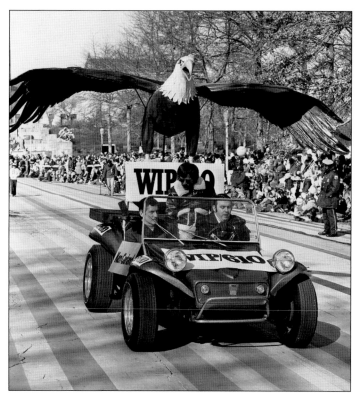

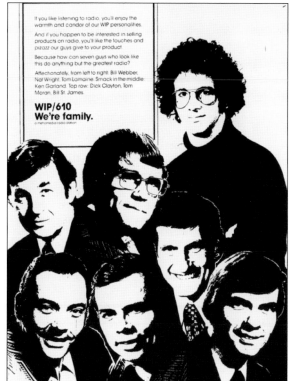

If you like listening to radio, you'll enjoy the warmth and candor of our WIP personalities.

And if you happen to be interested in selling products on radio, you'll like the touches and pizazz our guys give to your product.

Because how can seven guys who look like this do anything but the greatest radio?

Affectionately, from left to right: Bill Webber, Nat Wright, Tom Lamaine. Smack in the middle: Ken Garland. Top row: Dick Clayton, Tom Moran, Bill St. James.

WIP/610
We're family.
a metromedia radio station

The WIP announcer lineup in 1974 included some of the most well-known Philadelphia radio personalities. As a full-service adult contemporary station, the on-air staff was as important in entertaining the audience as the music itself. In the late 1970s, WIP was one of the last successful AM stations in Philadelphia to play new music.

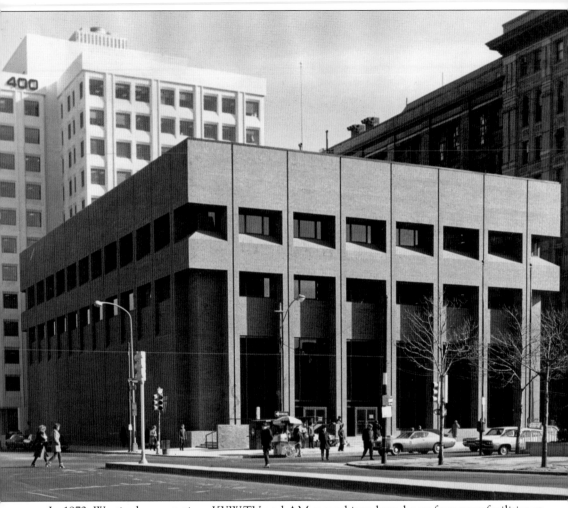

In 1972, Westinghouse stations KYW-TV and AM moved into brand-new four-story facilities at Fifth and Market Streets on Independence Mall, referred to by locals as the KYW Building. In 1990, Westinghouse purchased WMMR and eventually moved it into the building as well. After a series of mergers, the stations became part of CBS, which sold WMMR. WMMR moved out of the building in 1997 at the same time newly acquired WYSP moved in. Ten years later, the building was sold and demolished to make way for the new National Museum of American Jewish History. KYW-TV moved to Hamilton Street, and the radio stations moved into the 400 Market Street building, seen in the background of this 1972 photograph. (Courtesy of Temple University Libraries, Urban Archives, Philadelphia, Pennsylvania.)

KYW announcers Dick Covington (right) and Bill Bransome (below) are seen in Studio K, the air studio at the Fifth and Market Street facility in 1975. KYW switched to an all-news format in September 1965. From 1956 to 1965, the station was known as WRCV under NBC ownership. Westinghouse, which owned the station prior to 1956, regained control in 1965, returning the call letters to KYW and quickly launching the all-news format. Sister station WINS New York had been one of the first stations to switch to all news earlier that spring. Covington's voice can still be heard today in a recorded announcement played at the top of every hour on KYW. (Both, courtesy of Temple University Libraries, Urban Archives, Philadelphia, Pennsylvania.)

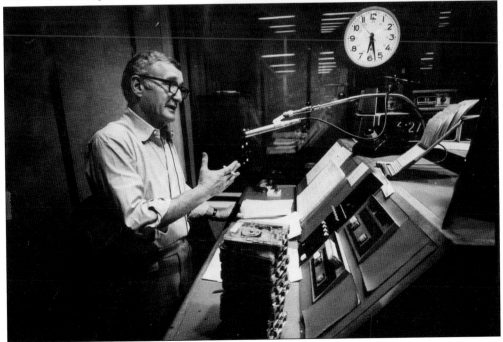

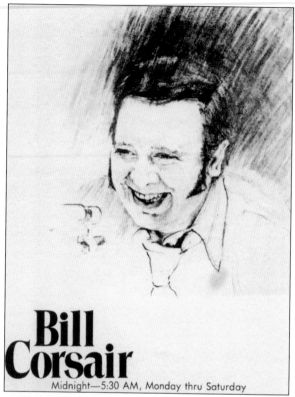

Bill Corsair was the host of a popular overnight talk show on WCAU-AM in the 1970s. Callers to the show were asked to pick a CB radio-like handle instead of using their real names. A world record was set one night in 1974 when over 355,000 callers attempted to reach the show. Corsair also had a short stint at WFIL before leaving Philadelphia.

Bill Corsair

Midnight—5:30 AM, Monday thru Saturday

Mayor Frank Rizzo (below) introduces the first song on the new oldies format of WPEN-AM and FM on March 3, 1975. The station had been off the air for 56 days in order to complete a $250,000 renovation of the studios and transmitter. (Courtesy of Temple University Libraries, Urban Archives, Philadelphia, Pennsylvania.)

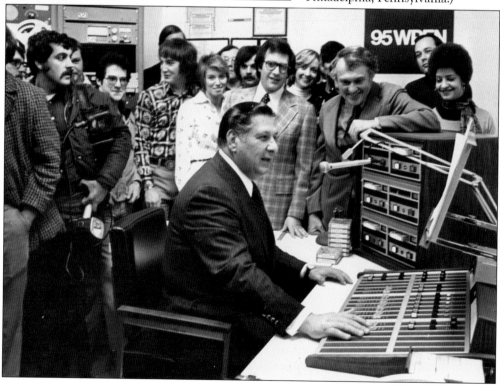

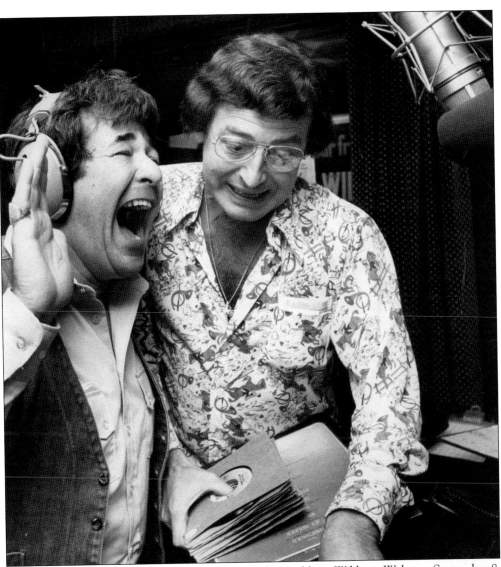

Hy Lit (left) and Joe Niagara are pictured during the weeklong Wibbage Wake on September 8, 1977, two days before WIBG signed off for the last time. It was an opportunity for former jocks to stop by, reminisce, and pay tribute to a Philadelphia institution. It is a rare occasion when a station gives any advance notice of changing format, let alone providing a full week for a farewell broadcast. With most music programming quickly migrating to FM, the station's new incarnation as Top 40 Wizzard 100 and subsequent disco format could not find a sufficient audience. After a nearly 25-year run with a religious format, the station became conservative news-talk WNTP in 2004. (Above, courtesy of Temple University Libraries, Urban Archives, Philadelphia, Pennsylvania.)

WIZZARD 100

WZZD THE PHILADELPHIA LIFESTYLE

After two years as a country music station, WFIL returned to the sounds of its glory days from the 1960s and 1970s on September 2, 1983. Former boss jock Jim Nettleton and the original jingles returned along with new versions of some of the old promotions, such as the Prize Patrol. Joey Reynolds, pictured below, had been a disc jockey at WIBG in the 1970s and hosted the WFIL morning show during the boss revival in the mid-1980s. Unlike the weeklong Wibbage Wake that closed out WIBG, WFIL faded away quietly as a satellite-delivered oldies station in 1989. The WFIL call letters were eventually restored, and the station now programs a religious format. (Photograph by © Scott Weiner.)

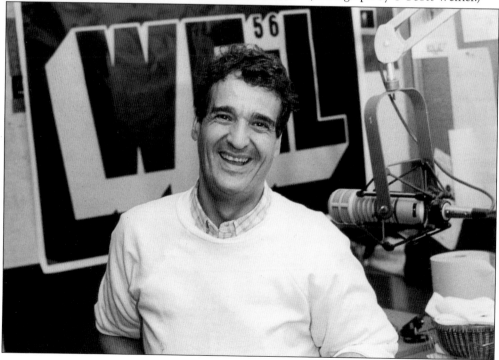

Four

THE RISE OF FM

FM radio was invented by engineer Edwin Armstrong in the 1930s to address the shortcomings of standard AM radio: undesirable static and lack of sound quality. FM offered a vast improvement in the audio quality of broadcasts. By World War II, around a half-million FM radios had been sold. However, after the war, the FCC reassigned the FM frequencies, which rendered all existing receivers obsolete, severely delaying the adoption of FM radio by the listening public.

Despite its technical superiority, FM languished for years due to poor sales of compatible radios. In 1956, only 229,000 FM radios were sold in the United States. By 1960, with increasing interest in consumer high-fidelity equipment, FM radio sales steadily rose. It would take another 17 years for FM radio to match AM in number of listeners. Initially, there was not much money to be made in FM radio, and the few stations on the air with original programming were kept alive by pioneers that had hopes for more success down the road.

One of the earliest forms of programming that was successful on FM was instrumental versions of standard and popular music, a format known as easy listening or beautiful music. In Philadelphia, over half of the FM stations played this format at some point, and it became synonymous with the FM band. One FM radio ad sales representative in the 1960s was often asked, "Is it radio or is it FM?" when he would attempt to solicit business.

The city's first FM station to begin regular broadcasts was station W53PH, later renamed WFIL-FM and today known as WIOQ. Participating in the inaugural broadcast are, from left to right, Samuel Rosenbaum, WFIL president; Robert Johnson, president of Temple University; Roger W. Clipp, the station's general manager; George Johnson, chairman of WFIL's board and president of Lit Brothers; and Maj. Edwin L. Armstrong, the inventor of FM. The ceremony took place at the station's studios on the 18th floor of the Widener Building at Broad and Chestnut Streets on November 10, 1941. W53PH transmitted from an antenna atop a 250-foot tower located on the roof of the building. In 1942, the station published a program booklet that was mailed to more than 1,300 listeners. (Both, courtesy of the Historical Society of Pennsylvania.)

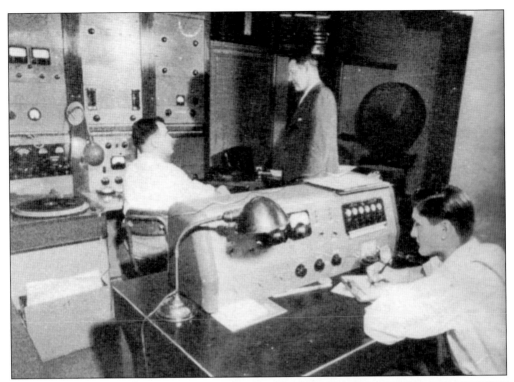

In 1946, Walter Annenberg's Triangle Publications, which also published the *Philadelphia Inquirer*, purchased WFIL AM and FM. A 1947 booklet presented by the company detailed big plans for FM radio, as well as television and facsimile broadcasting (the transmission of printed materials). In this photograph taken from inside the WFIL-FM control room are, from left to right, Ray Rodgers, Chester Geise, and Frank Unterberger Jr. Even with a negligible listening audience, WFIL-FM maintained original programming separate from its AM operation in this facility located within the Widener Building. (Both, courtesy of John S. Flack Jr.)

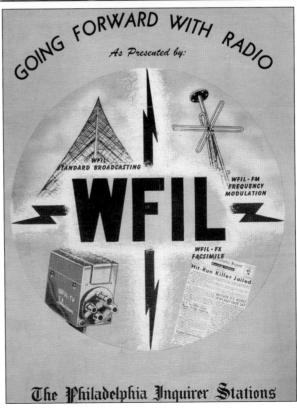

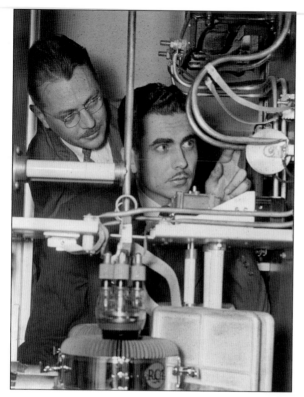

WCAU operated an early FM station called W69PH that went on the air for the first time on November 2, 1941. WCAU had been experimenting with FM broadcasting since 1939. In this photograph, station director Kenneth Stowman (left) and technical director George Lewis inspect the 10,000-watt transmitter. (Courtesy of the Historical Society of Pennsylvania.)

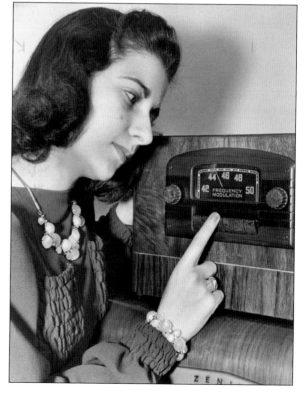

Phyllis Whitehead is seen operating a frequency modulation (FM) converter in the WCAU Building at 1622 Chestnut Street. These converters allowed regular AM radios to receive FM broadcasts. The dial displays the original FM band of 42 to 49 MHz, which was changed by the FCC in 1945 to the present 88 to 108 MHz. (Courtesy of Temple University Libraries, Urban Archives, Philadelphia, Pennsylvania.)

In 1947, WFIL-FM began broadcasting an eight-page weekly facsimile edition of the *Philadelphia Inquirer* to be printed out by specially equipped home radios. The system required four minutes to send each page. The FM facsimile system, decades ahead of its time, never caught on with the public. The transmitting equipment was eventually donated to Temple University and forgotten. (Courtesy of John S. Flack Jr.)

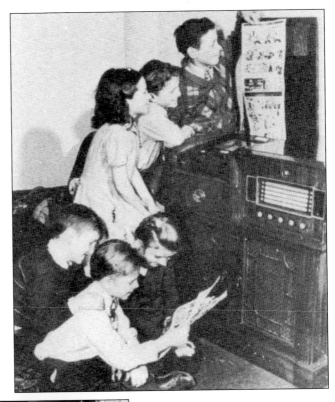

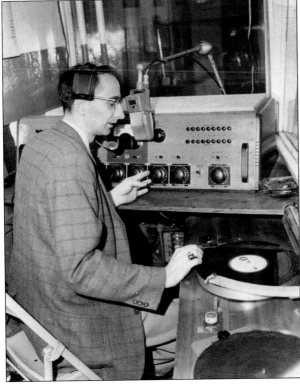

WPWT was an FM station established by the Philadelphia Wireless Technical Institute in 1950. W. Wayne Zerfing, the manager and chief engineer of the station, is seen here at the console in 1957. WPWT shared time with Drexel University's WKDU on 91.7 FM and was popular for its disco format in the 1970s and modern Top 40 format in the early 1980s. The station ceased operations in the late 1980s. (Courtesy of the Print and Picture Collection, Free Library of Philadelphia.)

WFLN, Philadelphia's classical and fine arts station, was established by a group of civic leaders, including Raymond Green, and signed on the air on March 14, 1949. Unlike most stations that began with an AM operation and then added an FM, WFLN began with an FM station and added an AM station in the late 1950s. The superior FM audio quality was considered more appropriate for the classical music format, and sophisticated classical music listeners were more likely to own FM radios. In addition to classical music, WFLN aired various features and interviews by legendary hosts such as Ralph Collier and Taylor Grant. Grant's late afternoon commentary, *Something to Say*, which aired from 1960 to 1972, was renowned for backing unpopular causes and stirring occasional controversy. (Courtesy of the Theatre Collection, Free Library of Philadelphia.)

One of the benefits of the newly expanded FM band was the inclusion of a section of noncommercial educational stations from 88 to 92 MHz. One such station was WHYY, which signed on the air on December 14, 1954, from a fully functional radio station at Seventeenth and Sansom Streets that was donated by Westinghouse Broadcasting. In the above photograph, volunteers distribute FM radios, which were rare at the time, to school classrooms in 1955. Below, Joe Burton is pictured at the WHYY console in 1957. The first programming from National Public Radio aired in 1971. (Both, courtesy of WHYY.)

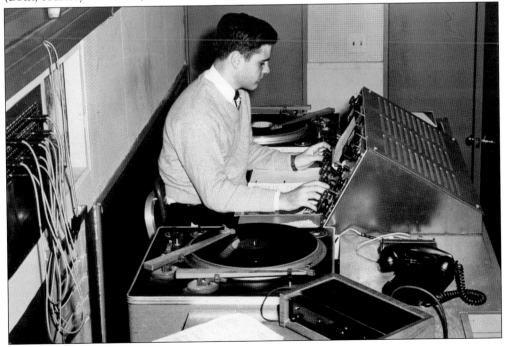

WQAL went on the air in 1959 from a small wooden shack at the base of its antenna tower on Mermaid Lane in Wyndmoor. Within a year, it was the number one FM station in Philadelphia, despite very little publicity. The poster pictured here was one of the few ways the station promoted itself. Despite being the number one FM station, WQAL's audience was a small fraction of many AM stations, so there was little advertising revenue and operating costs were kept to a minimum. On occasion, owner Abe Voron was asked about selling the station. His standard response was reportedly, "It's not for sale, but if you want to buy it, it's a million dollars." In 1970, with the value of FM stations quickly rising, United Artists took Voron up on his offer and became the new owners of WQAL. (Courtesy of David J. Custis.)

Dave Custis was the first voice heard over WQAL in 1959 and was responsible for most of the station's early programming. The station played a wide variety of non-rock programming, including instrumentals, show tunes, and popular music of the day with many records coming from Custis's own collection. (Courtesy of David J. Custis.)

In 1961, bandleader Stan Kenton participated in a live broadcast for WQAL at Gerhard's Record Shop in Glenside. Until the mid-1960s, original programming on FM stations was mainly aimed at an adult audience such as Kenton's. (Courtesy of David J. Custis.)

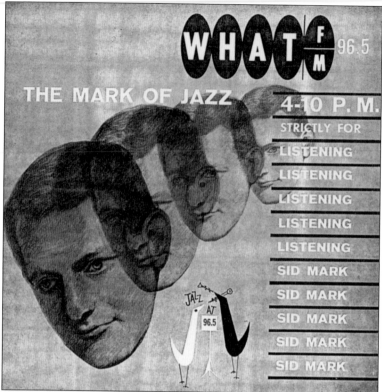

Beginning in 1956, WHAT-FM became one of first 24-hour jazz stations in the country. Sid Mark was one of the station's four announcers and also hosted the long-running Frank Sinatra programs *Friday with Frank* and *Sunday with Sinatra*. Some of the musicians that stopped by the station during the jazz years included Nina Simone, Nancy Lewis, Ramsey Lewis, Ahmad Jamal, Buddy Rich, and Woody Herman.

Sid Mark is pictured at the console of WWDB, the successor to WHAT-FM, on March 13, 1975, just days before the station dropped the all-jazz format and began a successful 25-year run as one of the nation's first talk stations on FM. (Courtesy of Temple University Libraries, Urban Archives, Philadelphia, Pennsylvania.)

The John Trent Show was heard over the *Philadelphia Bulletin*–owned station WPBS (now WUSL) weekdays from 9:00 a.m. until noon in the 1960s. It was one of the only, and likely one of the last, daytime radio programs described by the station's promotional material as "devoted exclusively to the Homemaker." Trent was an originator of the Housewives Protective League, a programming concept devoted to the promotion of quality products and services for women. Trent spent 15 years at WCAU before joining WPBS, which signed on in 1961. Along with Trent's program, the station played a wide variety of standards, show tunes, and orchestral music. By the mid-1970s, with homemakers more difficult to find, the station switched to an instrumental easy listening format. (Right, courtesy of the Theatre Collection, Free Library of Philadelphia.)

HAPPiNESS iS....

LiSTENiNG TO THE SMOOTH SOUND

ON

WPBS STEREO 99FM

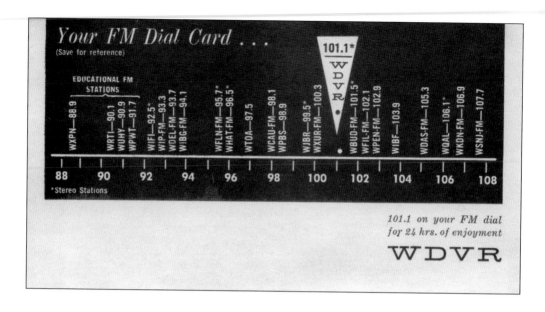

Engineer David L. Kurtz founded WDVR, which signed on May 13, 1963. Business partner and eventual station owner Jerry Lee is credited with marketing and promotion innovations that helped turn FM radio into a profitable business. WDVR printed and gave away a million dial cards on the street and in stores throughout the region. In addition to prominently featuring WDVR's dial position, it also showed the location of the other FM stations in the spirit of "rising tides lift all ships," according to Lee. Four months after launching, WDVR was the number one FM station in Philadelphia. Other Lee innovations included the first big money giveaway in radio and the first professional television commercial for a radio station. WDVR also had the distinction of being the first FM radio station to bill $1 million in advertising sales, which occurred in 1968. (Both, courtesy of Dave Shayer.)

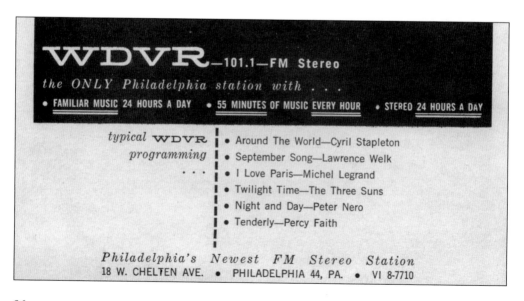

Joaquin Bowman was one of the original announcers on WDVR, seen here at the station's console in June 1963. The studio and transmitter was initially located in the Barker Building on Chelten Avenue in Germantown. WDVR took advantage of FM stereo, which had just been approved in 1961, and was one of the few stations to broadcast in stereo 24 hours a day. (Courtesy of Dave Shayer.)

In 1967, WDVR moved to new studios at 10 Presidential Boulevard, where Dave Shayer (left) and Allan Dean are pictured above in 1971. Shayer was one of the original announcers on WDVR, and Dean was one of the overnight disc jockeys on WIBG in the 1960s. (Courtesy of Dave Shayer.)

These are a few of our BEAUTIFUL THINGS

WDVR'S "007" JAMES BOND CAR
WDVR'S YACHT "EAGLE ONE"
WDVR'S PENTHOUSE

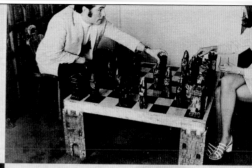

WDVR - 101 FM MUSIC FOR

WDVR released a record album in 1970 to promote its "beautiful music for beautiful people" campaign. The album's center gatefold offered images of an exciting, upscale world that could be had—but only by listening to WDVR. In reality, the items depicted were actual conversation pieces

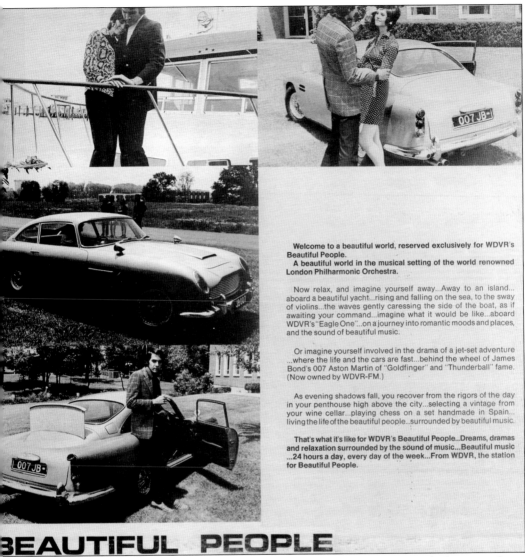

Welcome to a beautiful world, reserved exclusively for WDVR's Beautiful People.

A beautiful world in the musical setting of the world renowned London Philharmonic Orchestra.

Now relax, and imagine yourself away...Away to an island... aboard a beautiful yacht...rising and falling on the sea, to the sway of violins...the waves gently caressing the side of the boat, as if awaiting your command...imagine what it would be like...aboard WDVR's "Eagle One"...on a journey into romantic moods and places, and the sound of beautiful music.

Or imagine yourself involved in the drama of a jet-set adventure ...where the life and the cars are fast...behind the wheel of James Bond's 007 Aston Martin of "Goldfinger" and "Thunderball" fame. (Now owned by WDVR-FM.)

As evening shadows fall, you recover from the rigors of the day in your penthouse high above the city...selecting a vintage from your wine cellar...playing chess on a set handmade in Spain... living the life of the beautiful people...surrounded by beautiful music.

That's what it's like for WDVR's Beautiful People...Dreams, dramas and relaxation surrounded by the sound of music...Beautiful music ...24 hours a day, every day of the week...From WDVR, the station for Beautiful People.

BEAUTIFUL PEOPLE

owned by the station as a savvy way to win business from potential clients and advertising firms. Jerry Lee, who still owns the station (now called B101), sold the Aston Martin pictured at auction in 2010 for $4.6 million, with the proceeds donated to charity. (Courtesy of Dave Shayer.)

COMES THE REVOLUTION, HY SKI'S UNDERGROUND IS ALREADY THERE.

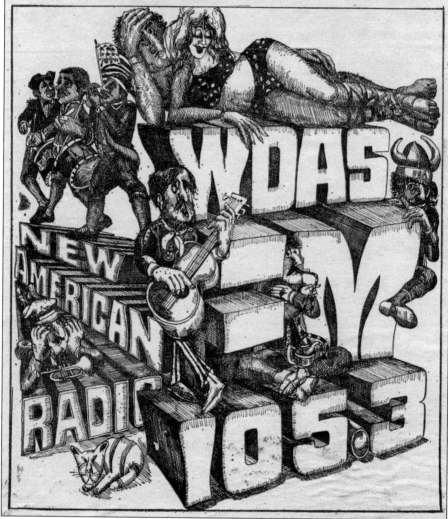

Three Philadelphia radio stations began progressive programming in the spring of 1968: WDAS-FM, WIFI, and WMMR. WDAS-FM's progressive format consisted predominantly of deep album cuts along with some classical music and rhythm and blues thrown in. The disc jockeys often played songs in long sets and spoke about the music in a laid-back, conversational manner. Some even recited poetry. WIFI and WMMR gradually phased in the format over a period of months and years, while WDAS-FM completely dropped their classical/jazz format to go progressive full-time, the first in the city to do so. Initially, their effort was called "Hy Ski's Underground" led by Hy Lit, who left WIBG to chart new territory on the emerging FM band after a stint on WDAS-AM. The WDAS staff also included Ed Sciaky, Gene Shay, Steve "My Father's Son" Leon, Wayne Joell, Michael Tearson, T. Morgan, Ron Sockel, Steve Marko (also known as Steve Martorano), Larry Magid, and Rod Carson. (Courtesy of the Bob Klein Archive and WDASHistory.com.)

HERMAN

your host at Woodstock

and...

Dark roots of song flung
to the outer limits.

Arlo and Otis, Dylan and Donovan,
Bach and The Beatles rippling in sound
waves over the sands of time.

Yesterday's hopes, today's blues
and tomorrow's dreams roll across
your mind, seeking out your soul.

The Marconi Experiment,
nightly,

9 PM-1 AM

WMMR 93 3

Metromedia Stereo in Philadelphia

WIP-FM was renamed WMMR in July 1966 in an attempt to strike out on its own and leave the shadow of popular sister station WIP-AM. Initially, this new effort consisted of middle of the road music with prerecorded announcers. On April 29, 1968, *The Marconi Experiment* debuted live with host Dave Herman, incorporating the underground music and ideals of the 1960s youth culture. The popularity of this one program led the station to adopt a full-time progressive format in October 1969. WMMR continued to build on this foundation over the ensuing decades to become one of the most successful rock stations in the city. (Courtesy of WMMR.)

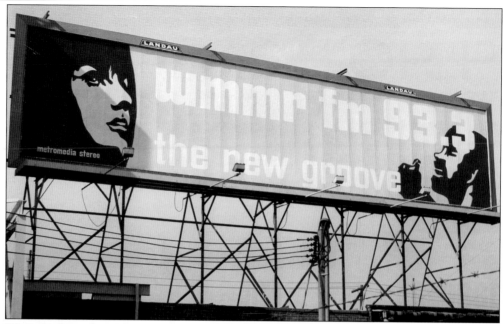

WMMR's first advertising campaign in 1970, dubbed "the new groove," included this billboard. (Courtesy of WMMR.)

Gene Shay is a Philadelphia folk music institution who has shared his deep knowledge of the genre with radio listeners since the mid-1960s. Shay's resume includes stops at WHAT-FM, WDAS-FM, WMMR, WIOQ, WHYY, and WXPN, as well as numerous creative positions in the local advertising field. (Courtesy of WMMR.)

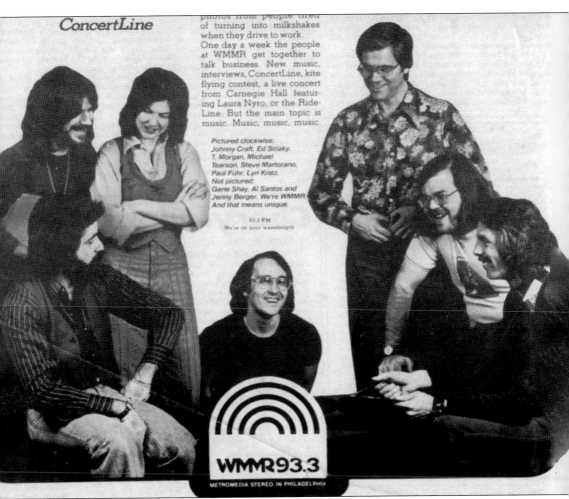

ConcertLine

photos from people tired of turning into milkshakes when they drive to work. One day a week the people at WMMR get together to talk business. New music, interviews, ConcertLine, kite flying contest, a live concert from Carnegie Hall featuring Laura Nyro, or the Ride-Line. But the main topic is music. Music, music, music.

Pictured clockwise:
Johnny Craft, Ed Sciaky, T. Morgan, Michael Tearson, Steve Martorano, Paul Fuhr, Lyn Kratz.
Not pictured:
Gene Shay, Al Santos and Jenny Berger. We're WMMR. And that means unique.

93.3 FM
We're on your wavelength

WMMR 93.3
METROMEDIA STEREO IN PHILADELPHIA

This 1976 advertisement shows many of the early-air staff at WMMR. The station has been the launching pad for some of the most knowledgeable and well-known radio personalities in rock. Pictured from left to right are (seated) Steve Martorano, Michael Tearson, Ed Sciaky, and T. Morgan; (standing) Paul Fuhr, Lyn Kratz, and Johnny Craft. (Courtesy of WMMR.)

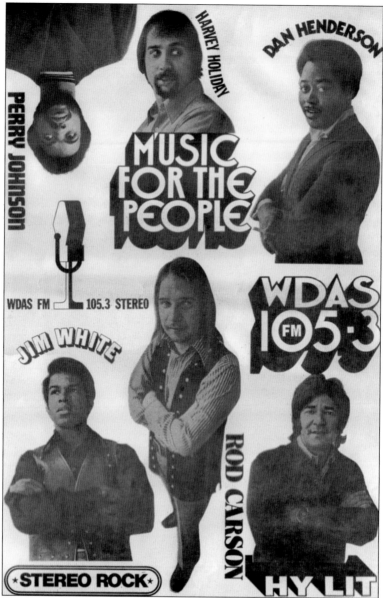

Around 1971, the underground/white rock–dominated sound at WDAS-FM was phased out in favor of a newly designed format, the brainchild of WDAS general manager Bob Klein. The new music library included album-oriented rhythm and blues, hard-driving rock, protest songs, jazz, and even contemporary poetry. Historian Wynne Alexander explains, "Bob Klein came up with the idea and went to Harvey Holiday who came up with the slogan 'Music for the People' and together they implemented it, revamped the staff and created an outstanding, first of its kind format with a huge and varied playlist. The jocks were able to mix amazing musical sets from a wildly diverse record library: B. B. King to Carole King, Sly Stone to the Rolling Stones, Santana, Bob Dylan to gospel groups singing Dylan, Richie Havens, Osibisa, The Meters, The Crusaders, the Persuassions—just a phenomenal mix of the best music in American history." This poster shows the disc jockey lineup early in the new format, a variant of which can still be heard on WDAS-FM today. (Courtesy of the Bob Klein Archive and WDASHistory.org.)

A new advertising campaign for WDAS-FM in the mid-1970s referred to the station's disc jockeys as the "FM Band." Featured in the advertisement are, from left to right, Jerry Wells, Wayne Joell, Louise Williams, Doug Henderson Jr., Dr. Perry Johnson, Brother Nasir, and Tony Brown. Louise Williams was famous for her gospel show on WDAS-AM, and the soaring popularity of Dr. Perry Johnson made him an FM phenomenon. (Both, courtesy of the Bob Klein Archive and WDASHistory.org.)

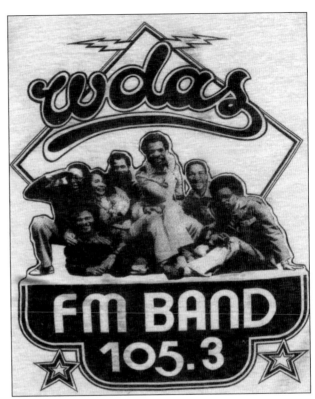

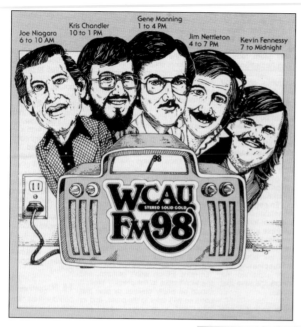

In 1972, WCAU-FM became the city's first full-time FM oldies station, with Jim Nettleton as program director. The operation was originally automated but evolved into a system whereby the on-air personalities worked alongside the automation equipment in a setup known as live assist. In 1976, WCAU-FM was called "disco radio" but soon infused their disco mix with jazz, pop, and rock music under the name "Fascinatin' Rhythm." In the late 1970s, WDAS-FM and WZZD (now WNTP) were also playing variations on the disco format. After a huge wave of popularity, a strong disco backlash around 1980 made the all-disco format extinct. (Left, courtesy of the Print and Picture Collection, Free Library of Philadelphia.)

Barry Resiman arrived at WIBF-FM in 1969, which was broadcasting from the basement of the Benson East Apartments in Jenkintown under the swimming pool. A fake, backlit window was added to the studio to give the illusion of daylight. In this photograph, Reisman is participating in a 1972 Heart Association fundraiser in which he was handcuffed to a Pennsylvania State constable. (Courtesy of Barry Reisman.)

When United Artists purchased WQAL in 1970, they changed the call letters to WWSH and continued providing easy listening music under the name "Wish." Dave Shayer, seen here in the studio in 1977, was an announcer at WWSH from 1974 to 1979. Although many Philadelphia stations offered the beautiful music format at one time or another, each one had subtle differences in their presentation. (Courtesy of Dave Shayer.)

Musician Al Stewart (right) is seen visiting host Ed Sciaky in the WIOQ studio around 1978 to promote his album *Time Passages*. Sciaky began his career at WHAT and then spent two years at WDAS-FM before landing at WMMR in 1970. He joined WIOQ in 1977 and would later go on to work for WYSP and WMGK. (Photograph by © Scott Weiner.)

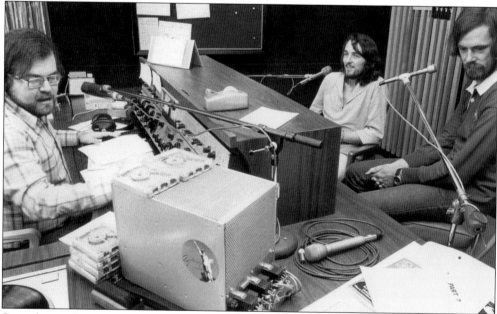

Seen above is WIOQ host Ed Sciaky (left) with Supertramp members Roger Hogson (center) and Rick Davies sometime around 1978. Sciaky was well known for his encyclopedic knowledge of rock music and his close friendships with many of the rock musicians he championed during his career. Many who knew him considered Sciaky a genius. (Photograph by © Scott Weiner.)

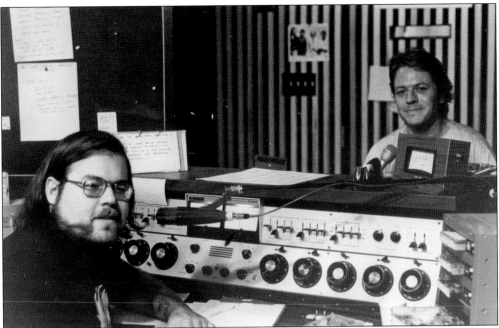

In this photograph, WIOQ's Ed Sciaky (left) poses with musician Robert Palmer in the studio. During the free-form radio heyday of the 1970s, disc jockeys on stations such as WMMR and WIOQ had the power to break unknown acts by taking risks and playing music they believed in. Both Bruce Springsteen and Billy Joel have credited Ed Sciaky for being one of the first radio hosts to expose their early music to listeners. (Photograph by © Scott Weiner.)

WIOQ played a broad progressive mix of music in the late 1970s. The station's staff is seen here with musician Jean-Michel Jarre. From left to right are Ed Sciaky, John Harvey (of *Harvey in the Morning* fame), unidentified, Jean-Michel Jarre, Helen Leicht, and program director Alex DeMers. (Photograph by © Scott Weiner.)

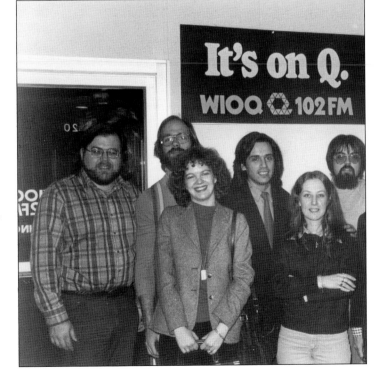

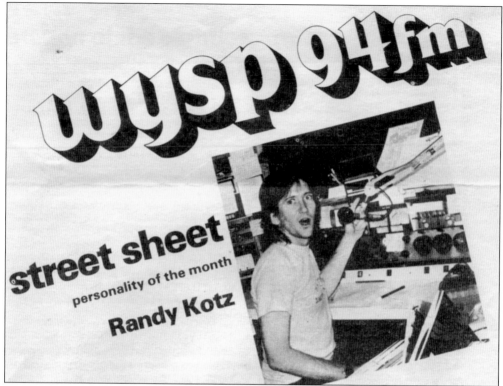

WYSP was one of the pioneers in album-oriented rock, beginning in 1973 with a format known as SuperStars. By the late 1970s, WYSP was considered by advertising agencies to be one of the best FM stations for reaching 18 to 34 year olds. At the time, this age group was the first generation of rock fans that had been raised on this music and had little knowledge about any other type. Album-oriented rock was an evolution of the progressive sound but with a more restricted playlist. Here, WYSP disc jockeys Randy Kotz and Cyndy Drue are seen in the air studio around 1980. (Below, courtesy of Cyndy Drue.)

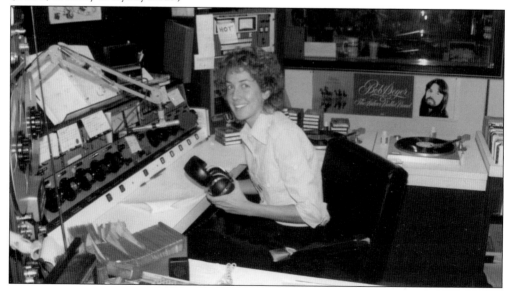

From the mid-1970s through 1979, WYSP's Bob Leonard (left) and Sonny Fox hosted the *Fox and Leonard* morning show. One of the first two-man morning teams in Philadelphia radio, their humorous program was loosely modeled after the legendary comedy team of Bob and Ray. (Courtesy of Bob Leonard.)

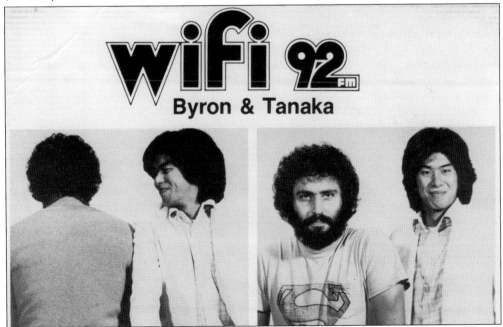

Paul Byron (left) and T.N. Tanaka (Ed Higashi) hosted the *Byron and Tanaka* morning show on WIFI from 1977 to 1980. Personality-driven radio teams were new to FM radio in the 1970s but commonplace by the 1980s. Byron and Tanaka took their comedy-based show to KFI in Los Angeles after leaving WIFI. (Courtesy of Ed Higashi.)

Dave Klahr programmed two early and successful FM soft rock stations in Philadelphia: WFIL-FM in the early 1970s and WMGK, which launched on September 2, 1975. Klahr is seen here at the 1976 holiday party in the WPEN Building at 2212 Walnut Street, which also housed sister station WMGK. (Courtesy of Harry Neyhart.)

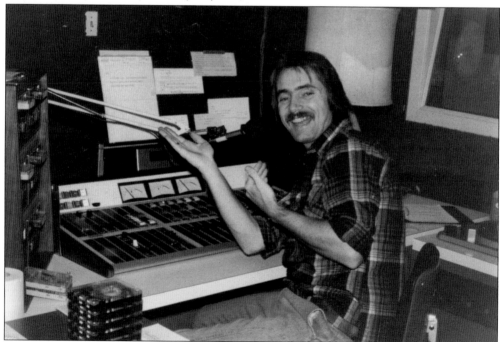

Peter Booker was the first voice heard on WMGK's new format, known as Magic 103. WMGK became a model for FM adult contemporary stations around the country and was extensively copied. (Courtesy of Harry Neyhart.)

On August 7, 1980, singer Carly Simon visited WMGK and was interviewed by host Tom Richards. At that time, WMGK was one of the top 10 stations in Philadelphia, providing a mix of soft contemporary rock music and a popular weekly concert series. The station targeted an adult audience and emphasized the music more than the disc jockeys. (Both, courtesy of Harry Neyhart.)

wmgk•fm magic 103

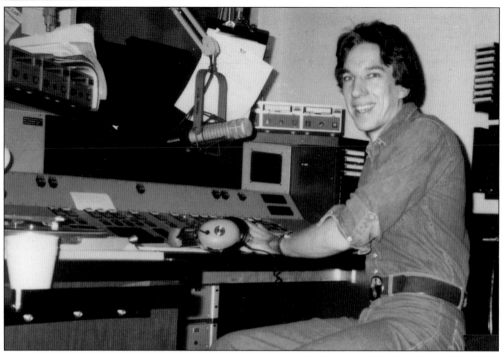

Another FM station that had early success with the adult contemporary format was WUSL, also known as US1. Randy Roberts is seen here in the studio of WUSL around 1980, just before the station decided to switch to a country format, based on the success of the movie *Urban Cowboy*. Today, the station plays hip-hop and rhythm and blues as Power 99. (Both, courtesy of Randy Roberts.)

On November 8, 1982, WKSZ (Kiss 100) went on the air at 100.3 FM, filling the last vacant frequency in the Philadelphia radio market. Mayor of Media, Pennsylvania, Frank Daly (above, left) and WKSZ president Dan Lerner are seen throwing the ceremonial power switch at the station's launch party. Starting from an audience of zero, WKSZ steadily grew its listener base to over 500,000 within five years and was extremely popular with female audiences. The station utilized a lip-shaped logo and somewhat controversial billboard and television campaign featuring artist Auguste Rodin's sculpture entitled *the Kiss*. In 1993, the station was renamed Y100 and became 100.3 The Beat in 2005. (Above, courtesy of Walter Faust; below, courtesy of Dan Lerner.)

Band members of the group Asia stopped by WMMR for an on-air interview with host Anita Gevinson in 1982. Pictured from left to right are Steve Howe, Asia guitarist; Carl Palmer, Asia drummer; Gevinson; John David Kalodner, Geffen Records; and Brian Lane, Asia manager. (Photograph by © Scott Weiner.)

In the early 1980s, WIOQ played an eclectic mix of music that included some soft rock, deeper album cuts, some Top 40 hits, and even a touch of jazz. Helen Leicht (right), host of the long-running *Breakfast with the Beatles* show, is seen here with singer and Broadway actress Karla DeVito in the WIOQ studio in 1981. (Photograph by © Scott Weiner.)

Ed Sciaky (right) and Billy Joel are pictured backstage at a concert in 1984. The friendship between the two men dates back to 1972, when Joel was virtually unknown and Sciaky was a disc jockey on WMMR who believed in Joel's talent and championed his music by giving it airplay. Ed Sciaky passed away on January 29, 2004, at the age of 55. (Photograph by © Scott Weiner.)

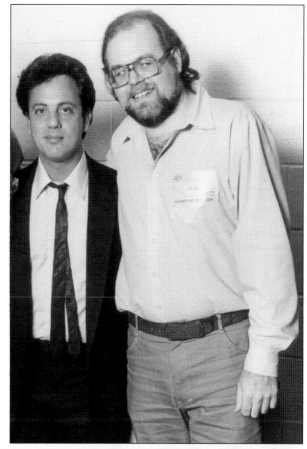

Cyndy Drue hosted *Street Beat* on WMMR from 1986 to 1996. The show's mission was to expose the music of local bands and musicians. Drue is pictured (left) with Ted Putnam, manager of the Tower Records South Street store. The two are standing in front of a display showcasing albums by bands featured on *Street Beat*. (Courtesy of Christine Kerrick.)

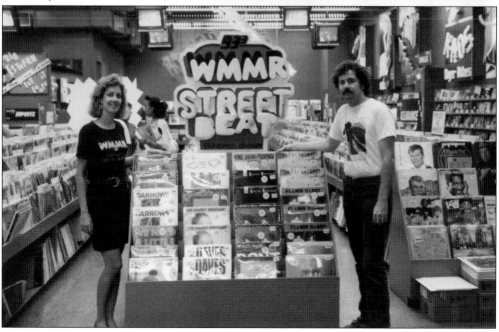

One of the most casual, comfortable studios in Philadelphia radio, complete with couches and chairs, belonged to WMMR when it was located in the Wellington at Nineteenth and Walnut Streets, overlooking Rittenhouse Square. Unlike most windowless air studios situated deep within the bowels of nondescript office buildings, WMMR staffers were able to roll up the window and share a vibe with the bustling world just a few feet away. (Both, courtesy of WMMR.)

WMMR disc jockey Pierre Robert is pictured enjoying access to the outdoors afforded by the station's unique location in the Wellington. WMMR moved into the stately building in 1962 when it was called WIP-FM and considered an afterthought in contrast to its popular AM sister station, WIP-AM. It was at this location that the station evolved into one of the city's top heritage rock outlets. In 1992, WMMR moved into the KYW Building at Fifth and Market Streets and is today based in Bala Cynwyd. (Both, courtesy of WMMR.)

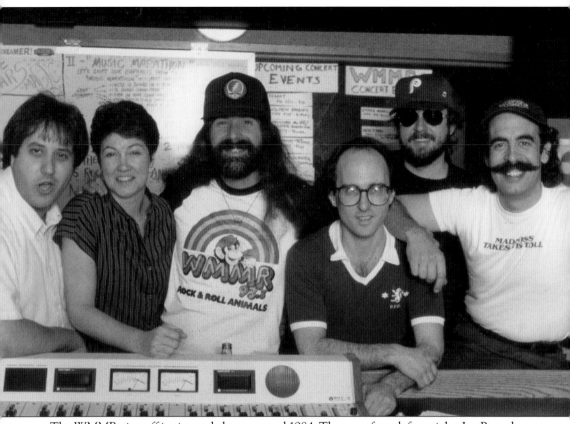

The WMMR air staff is pictured above around 1984. They are, from left to right, Joe Bonadonna, Lyn Kratz, Pierre Robert, Michael Tearson, John "Bubba" Stevens, and John DeBella. (Courtesy of WMMR.)

Head zookeeper John DeBella (left) is pictured here with Mark "the Shark" Drucker. John DeBella joined WMMR in 1982 as the morning personality and soon put together a zany cast of characters that became known as the *Morning Zoo*. Within three years, it became the number one FM morning show in Philadelphia, and two years after that, it overtook KYW for the top slot out of all the city's stations. Other members of the zoo included Chip Horaneck and Clay Heery. Some of the more popular events of the zoo era included the annual Debella DeBalls, Hawaiian Shirt Gonzo Fridays, and "Louie, Louie" parades based on the famous scene from *Ferris Bueller's Day Off*. (Both, courtesy of WMMR.)

Legendary disc jockey Pierre Robert's iconic flying hair photograph has been displayed on billboards throughout the Delaware Valley. Known for his friendly, laid-back persona, Robert has been on the air at the same station for 30 years, an unusual feat in the radio industry. (Courtesy of WMMR.)

A memorable television commercial for WMMR c. 1979 featured Rodney Dangerfield and a chimp posing as the station's general manager. This series of spots introduced the station's new slogan, "rock and roll animals." (Photograph by © Scott Weiner.)

WIFI disc jockey Mel "Toxic" Taylor poses with members of the Thompson Twins in 1983. From left to right are Joe Leeway, Tom Bailey, Taylor, and Alannah Currie. The Thompson Twins were a British new wave group that epitomized the type of music played on the memorable but short-lived "Rock of the 80s" format on WIFI. WIFI became country station WXTU in 1984. (Courtesy of Mel Taylor Media.)

Terry Gross is seen here around 1985, the year her show *Fresh Air* was distributed nationwide by National Public Radio (NPR). It now airs on over 450 stations, originating from the WHYY studios on Sixth Street in Center City. Gross joined WHYY in 1975 as producer and host of *Fresh Air*, which was then a local interview and music show. (Courtesy of WHYY.)

Two of the most popular Philadelphia Top 40 stations in the 1980s were Hot Hits WCAU-FM (1981–1987) and Eagle 106 WEGX-FM (1986–1993). Much like the WIBG and WFIL AM Top 40 formats of the 1960s, these stations featured personality-driven disc jockeys, high-energy presentation, and tight playlists. The main difference was that this format was now being offered on FM to a teen audience that had been weaned on FM and mostly ignored AM. Top 40 stations such as these became virtually extinct in the early 1990s because their listeners were deemed too young to interest advertisers and the rock genre was splintering into narrower categories. A Top 40 station used to play the hits regardless of whether they were considered soft rock, hard rock, urban, or dance, but today, such varied music is not likely to be heard together on one station.

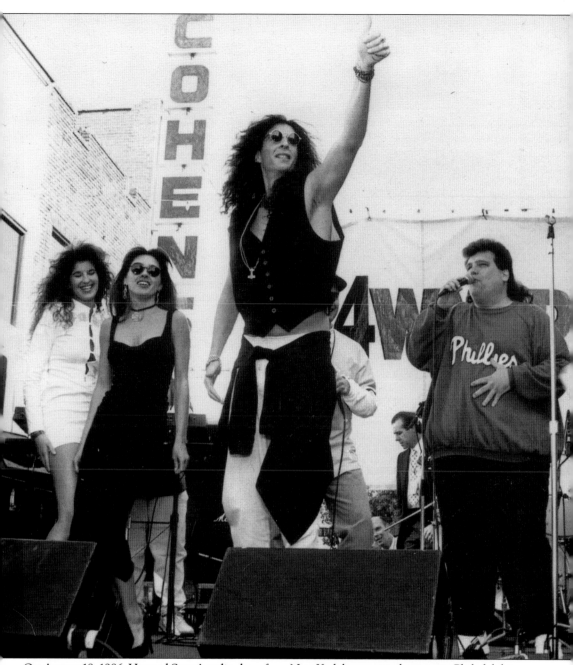

On August 18, 1986, Howard Stern's radio show from New York began simulcasting in Philadelphia on WYSP. The big question at the time was whether a morning show from another city could be successful in Philadelphia without the local flavor usually provided on such a program. It took three and a half years of radio warfare, but Stern eventually reached the top spot. The self-proclaimed "king of all media" is pictured here on a South Street stage in 1993 when he was in town to promote his book *Private Parts*. Eventually, Stern was carried in 60 markets nationwide until he left terrestrial radio for satellite radio in 2006. (Photograph by © Scott Weiner.)

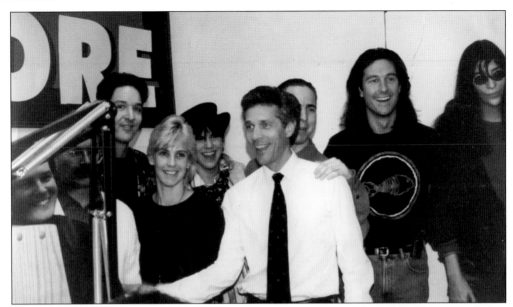

The first live broadcast on new alternative rock station WDRE on November 15, 1992 included, from left to right, Tom Calderone, Bob Marrone, Darren Smith, "Malibu" Sue McCann, "Donna Donna," Ron Morey, unidentified, Mel Toxic, and Joey Ramone. The station, formerly known as WIBF, gained a strong cult following as "Philly's Modern Rock," even after it signed off with the Bitterfest concert on February 7, 1997. (Courtesy of Mel Taylor Media.)

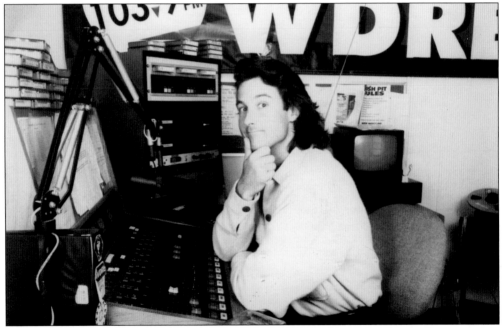

Mel "Toxic" Taylor is pictured at the console in the WDRE studios. Other local talent to emerge from WDRE included Preston Elliot and Steve Morrison of the *Preston and Steve* show, Bret Hamilton, Marilyn Russell, and Jim McGuinn (also known as Rumor Boy). When the station changed formats in 1997, many of the staff moved across town to Y100 (WPLY), which also programmed a modern rock format until 2005. (Courtesy of Mel Taylor Media.)

For nearly 50 years, WFLN (95.7 FM) and its classical music format was an institution in Philadelphia radio. During this time, the station's studios, transmitter, and self-supporting tower were located at 8200 Ridge Pike, seen here in 1995. In the mid-1990s, the station became the poster child for media consolidation in Philadelphia when it was sold five times over a period of 17 months at an ever-increasing price. Following months of speculation, WFLN dropped its classical music format on September 5, 1997, in favor of modern rock. By 2001, the station had moved out of this facility and today is known as Ben FM, a partially automated format that has a wide-ranging playlist. (Courtesy of Scott Fybush, fybush.com.)

www.arcadiapublishing.com

Discover books about the town where you grew up, the cities where your friends and families live, the town where your parents met, or even that retirement spot you've been dreaming about. Our Web site provides history lovers with exclusive deals, advanced notification about new titles, e-mail alerts of author events, and much more.

Arcadia Publishing, the leading local history publisher in the United States, is committed to making history accessible and meaningful through publishing books that celebrate and preserve the heritage of America's people and places. Consistent with our mission to preserve history on a local level, this book was printed in South Carolina on American-made paper and manufactured entirely in the United States.

This book carries the accredited Forest Stewardship Council (FSC) label and is printed on 100 percent FSC-certified paper. Products carrying the FSC label are independently certified to assure consumers that they come from forests that are managed to meet the social, economic, and ecological needs of present and future generations.

FSC
Mixed Sources
Product group from well-managed
forests and other controlled sources

Cert no. SW-COC-001530
www.fsc.org
© 1996 Forest Stewardship Council

Find Your Place in History.